IMAGES OF IRELAND

DUN LAOGHAIRE-RATHDOWN

IMAGES OF IRELAND

DUN LAOGHAIRE-RATHDOWN

PAT WALSH

NONSUCH

First published 2005
Reprinted 2006

Nonsuch Publishing
Lower Leeson Street
Dublin 2
Ireland

www.nonsuchireland.com
British Library Cataloguing in Publication Data.
A catalogue record for this book is available from the British Library.

ISBN 1-84588-500-7

Typesetting and origination by Tempus Publishing Limited.
Printed in Great Britain.

Contents

Acknowledgements

I would like to thank Alan Bailey, Nigel Curtin, Audrey Geraghty, Marie Jennings, Sean Kehoe and Billy O'Brien of the Local History Committee of the Library Service, Susan Lynch, Helen Power, Tiina Suvanto, Jonathan Duggan and Dympna Reilly, current and past staff of Dun Laoghaire Library for their hard work on this book over the last year. Don Griffin took some of the images used in the Ancient Spaces chapter. Thanks are also due to Shay Cannon and Pat Devereux for their unrivalled local knowledge and to all the rest of the staff of Dun Laoghaire-Rathdown Library Service for their help and co-operation.

Michael Corcoran and Liam Kelly of the National Transport Museum, Alex Findlater, Seamus Kearns, Rev. Patrick J. Mangan P.P., Des Ó Murchú, Brian Smith and Peter Scott were very helpful, providing images and information.

Colette O'Flaherty and Sara Smyth of the National Library, Colum O'Riordan of the Irish Architectural Archive, Tony Roche of the Department of the Environment, Heritage and Local Government and Lieutenant General Barry Hanan of the Irish Air Corps were also generous and cooperative.

Thanks are also due to Peter Holder of Irish Historical Pictures, J.J. O'Brien of The Collectors' Shop, Blackrock Market and Rex Roberts ABIPP for supplying some of the images.

I would like to thank the following for permission to reproduce the images:

Department of Environment, Heritage and Local Government Photographic Unit: p. 122 (below), p. 123 (above), p. 124, p. 125 (below).

Irish Air Corps Photographic Section: p. 30, p. 86 (above).

Irish Architectural Archive Photograph Collection: p. 16 (above), p. 27 (above), p. 100 (above), p. 117 (above).

National Library: p. 10, p. 11, p. 13 (below), p. 22, p. 25, p. 28, p. 29, p. 34, p. 35, p. 39, p. 42 (below), p. 43 (below), p. 44 (below), p. 46 (above), p. 48 (above), p. 62 (above), p. 71 (above), p. 77 (above), p. 78 (above), p. 93 (above), p. 98 (above), p. 105 (above), p. 116 (above), p. 119 (below).

National Transport Museum: p. 84 (above), p. 92, p. 94, and p. 96.

Rex Roberts ABIPP: p. 32.

Simmons Aerofilms p. 31 (above).

The image on p. 118 appears courtesy of the Very Reverend Patrick J. Mangan, P.P. St Michael's Church Dun Laoghaire.

Introduction

Dun Laoghaire is a town that has been shaped by transport. Essentially, the railway and the steam ship made Dun Laoghaire. Before the coming of these new forms of conveyance, it was just a small fishing village on the outskirts of Dublin little different than Dalkey or Blackrock.

Its closeness to Dublin meant it began to expand at the beginning of the nineteenth century and with the advent of the steam ship and the train, it grew rapidly. At the same time it underwent a number of name-changes. Pre 1821 it was Dunleary, it became Kingstown after the Royal Visit of King George IV in 1821 and the town reverted back to Dún Laoghaire in 1921. The name change to Kingstown focused public attention on the town and it's fashionable potential.

The Victorians took their leisure seriously. Kingstown, Blackrock, Dalkey and Killiney developed as resorts and watering holes and also as tourist destinations for day-trippers. The general area became known as Ireland's Riviera.

The Harbour, built from 1817 to 1860, was a massive investment in the future and when finished was one of the world's newest and safest artificial harbours of its time. In 1826 a steam-paddle powered Mail Packet service carrying mail and passengers on the Kingstown-Liverpool and the Kingstown-Holyhead routes was established.

These mail-boats and the later ferries that replaced them also became an access point to England. As emigration from Ireland increased, for many people it was from the decks of these ships that they saw Ireland for the last time.

The Dublin and Kingstown Railway was established in 1834, further contributing to the town's development. Its proximity to Dublin and the coming of the railway enabled it to become a commuter town for Dublin's professional classes.

By the mid-nineteenth century Kingstown had access to the most advanced, up-to-date and fastest means of transport at the time by land and by sea. It acted as a gateway to and from England at a time when the Act of Union of 1800 had strengthened the ties both political and commercial between the two countries.

The area benefited hugely from these simultaneous developments. During 1834, Kingstown received Town Commission status and by the end of the nineteenth century had established itself as not only a fashionable resort but as a business centre and an international port.

The opening in 1848 of the Holyhead-London Railway line added further impetus to the progress. The journey from Dublin to London could now be achieved in eleven hours. The railway and the harbour defined the character of the town and still does to this day. Dun Laoghaire has been the main passenger port on the sea-route between Dublin and Britain for almost two centuries now.

In 1921 Kingstown renamed itself Dun Laoghaire and in 1930 the town merged with Dalkey, Blackrock and Ballybrack to become the Borough of Dun Laoghaire.

In the twentieth century the hinterland of Dun Laoghaire developed as Dublin expanded and the towns of Dundrum and Stillorgan grew as both commercial and residential centres. Ireland's first purpose-built, large-scale shopping centre was opened in Stillorgan in 1966.

The administrative area of Dun Laoghaire-Rathdown was established in 1994 with the amalgamation of Dun Laoghaire Borough and the south-eastern part of Dublin County Council. It has a population of approximately 200,000, which makes it the third most populous local authority in the Republic of Ireland.

Dun Laoghaire-Rathdown sweeps from the Dublin Mountains down to the sea and includes the towns of Deansgrange, Dun Laoghaire, Blackrock, Dalkey, Killiney, Dundrum, Stillorgan, Shankill, Cabinteely and Sallynoggin in its area.

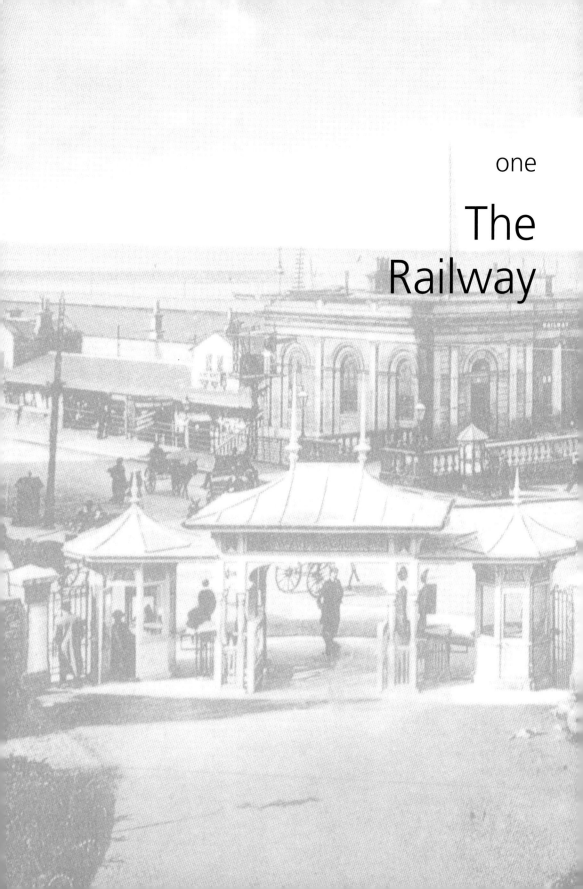

one

The Railway

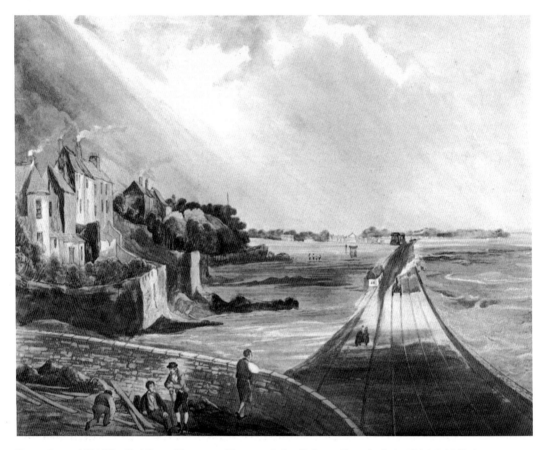

Engraving, *c.* 1834. The Dublin & Kingstown Line was Ireland's first railway, built in 1834. Initially it ran from Westland Row to Salthill. The original fares for a single journey were one shilling, 8d and 6d for first, second and third class respectively. This contemporary engraving, looking north from Blackrock towards Booterstown and Mount Merrion shows how the line was constructed. Once the line was completed it cut off that part of the sea to the left of the railway, creating Booterstown Marsh. The marsh is now a European Union listed bird sanctuary.

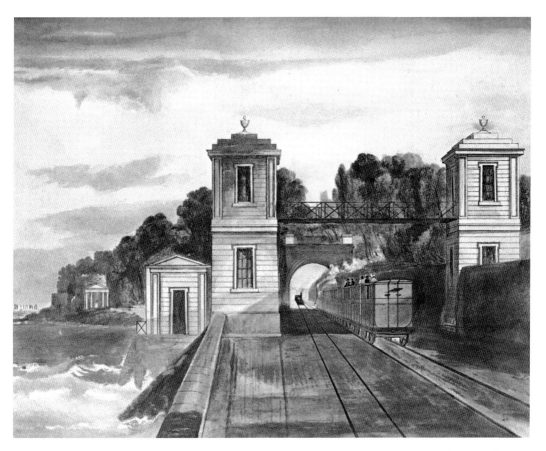

Engraving, *c.* 1834. The Dublin & Kingstown Railway committee encountered great difficulty with the purchase of land along the seafront particularly from Lord Cloncurry in Blackrock. Eventually he agreed to compensation of £2000, which at the time was a considerable amount. He also required the railway company to build this private footbridge for his use. William Dargan, the railway builder and entrepreneur won the tender to construct the railway for the cost of £83,000.

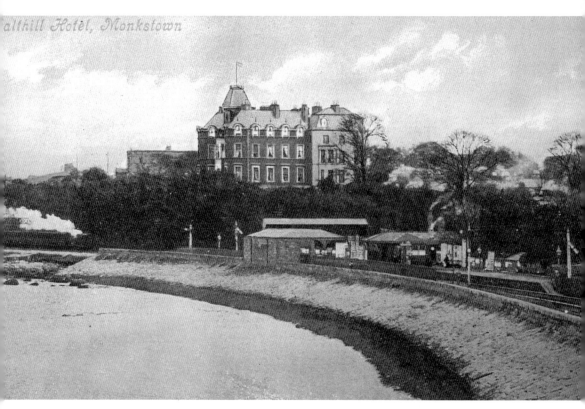

Salthill Station, *c.* 1900. Dublin & Kingstown Railway Company purchased the land surrounding Salthill House in case they needed it to construct the line. As it happened the land was not required and the Salthill Hotel opened in 1834 on the same day as the inaugural rail journey. D&KR was one of the first railway companies to own a hotel. To the left a train is about to pull in to the station. Originally the line terminated at Salthill and was only later extended to Kingstown Station. As can be seen the Salthill Hotel stood very close to the line which made it very popular and accessible for visitors to Dublin. Salthill itself takes its name from an eighteenth century salt works in the area.

Opposite, above and below: Salthill Station around, 1870. The hotel was rebuilt in 1865, a magnificent red brick structure with the air of a French chateau. William Thackeray was among those impressed by it and in his *Irish Sketch Book* called it a 'house devoted to the purpose of festivity … commanding a fine view of the bay and the railroad'. In this image it is clear that the baths (see below) had not yet been built. And as this advertising postcard states, having a 'Mild Winter' was regarded as a selling point. A footbridge over the railway allowed hotel guests access to the sea baths, which consisted of two stone-lined pools, one for gentlemen and one for ladies, with a dividing wall between them to ensure privacy. There was also a high wall to protect the bathers from the gaze of the train passengers. To the right some of the spires of Monkstown Church can be seen peering over the houses of Longford Terrace.

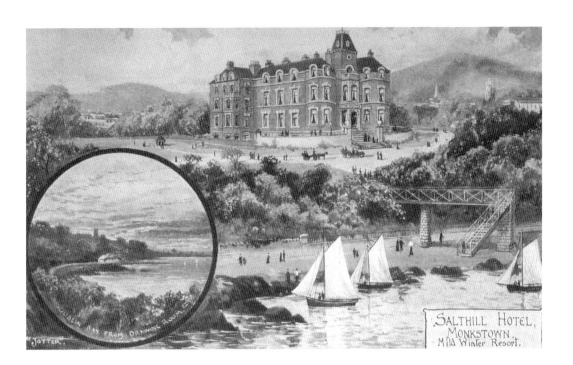

SALTHILL HOTEL,
MONKSTOWN,
Mild Winter Resort.

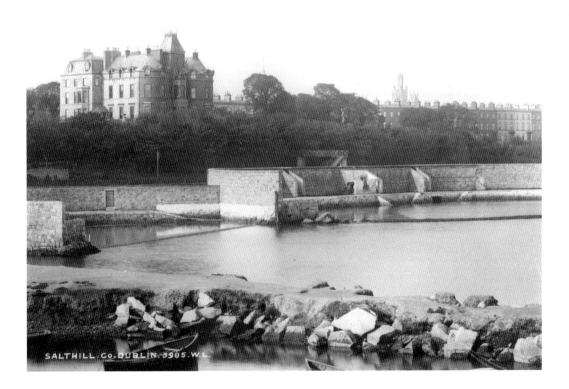

SALTHILL. Co. DUBLIN. 3985. W.L.

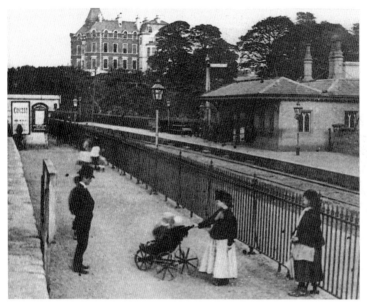

Salthill, *c.* 1900. In the 1920's the proprietors of the Royal Hibernian Hotel purchased the Salthill Hotel. Through the 1950's and 60's there was a gradual decline in its popularity. The hotel closed down in 1966 and lay derelict for a number of years. It burned down in 1972 and apartments were later built on the site. Note that the pram in the photograph seems to be of the three-wheeled variety.

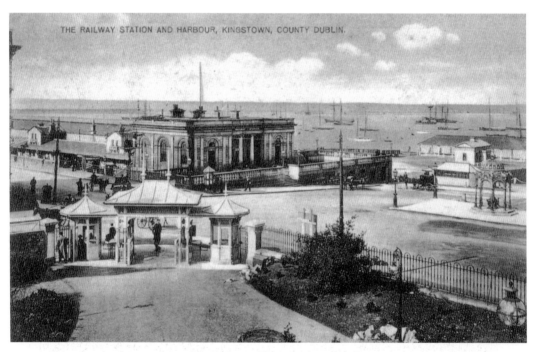

THE RAILWAY STATION AND HARBOUR, KINGSTOWN, COUNTY DUBLIN.

Railway Station & Pavilion Entrance, *c.* 1910. Kingstown Railway Station was designed by J.S. Mulvaney and built in 1845 at a cost of £2,800. It now houses Restaurant Na Mara. Initially the rail line was to terminate at Kingstown and many local businessmen strongly opposed its extension further south to Dalkey and Bray, fearing that the arrival of the railway might result in those towns rivalling Kingstown as a commercial centre and as a holiday resort. The Pavilion ticket office can be seen in the foreground. It benefited greatly from being so close to the railway station, especially with regard to day-trippers. The Kingstown Pavilion Gardens opened in 1903.

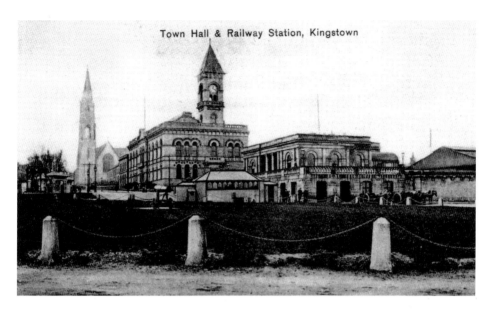

Railway Station & Town Hall, *c.* 1910. Opposition to the extension of the line was eventually overcome and work on the line to Dalkey was completed in 1844. The experimental line between Kingstown and Dalkey was known as the Atmospheric Railway, so called because it used air rather than steam to propel it. In this image a cannon can be seen, it was from the Crimea and is now on the East Pier. The building to the right of the cannon was a small tearoom.

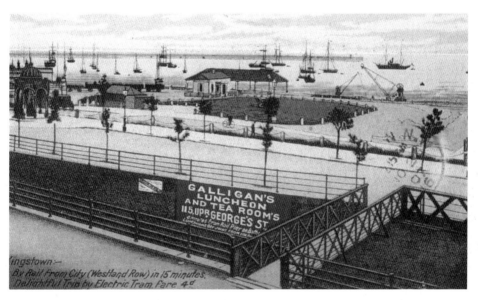

Kingstown Railway Sign, *c.* 1900. As can be seen from the advertisement for Galligan's Luncheon And Tea Rooms the five and a half miles rail journey to the city centre took fifteen minutes. A present day journey on the DART line would take eighteen minutes. Galligan's Tea Rooms was on a part of Upper Georges Street that was demolished in 1974 to make way for a shopping centre. Note that the sign has a superfluous apostrophe (tea room's) which goes to show that it is not just a modern grammatical error.

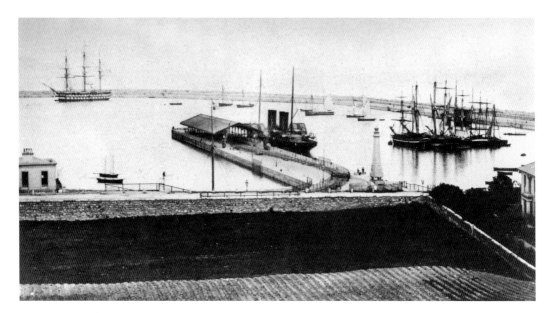

Above and below: Carlisle Pier, *c.*1870. The construction of the railway and the completion of the Carlisle Pier in 1859 meant that Kingstown was much more easily reached by sea and by land. The journey from London Euston to Carlisle Pier was scheduled to take eleven hours in 1860. The Royal Mail Packet Steamship *Connaught* could, the weather being calm, make the crossing of the Irish Sea in three and quarter hours. The Pier was specially constructed as the Mail Packet terminal. The Royal Navy guard ship can be seen in the background. The George IV Obelisk is to the right. It is still at the same location though its surroundings have changed greatly. The boat train ran past Dun Laoghaire Station directly on to Carlisle Pier. As can be seen in the image from the 1920s (below) this direct access was particularly convenient for foot passengers.

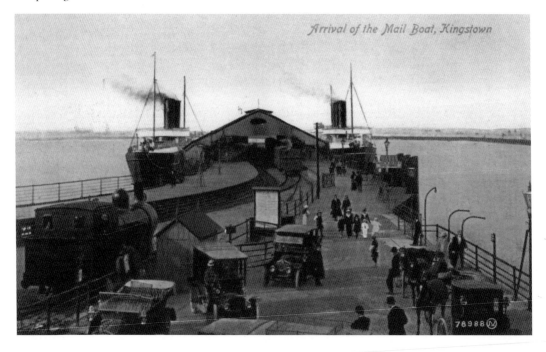

Arrival of the Mail Boat, Kingstown

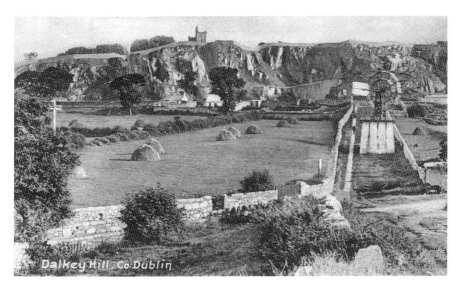

Above: Most of the granite for the building of Kingstown Harbour was taken from Dalkey Quarry. A small funicular railway along a track popularly known as 'The Metals' transported the stone downhill, the weight of the descending trucks pulling up the empties. The pathway beside the track is still known as The Metals. The passenger line evocatively known as the Atmospheric Railway opened in 1844. It also used gravity in the downhill journey from Dalkey to Kingstown and suction on the uphill run in the other direction. There were technical difficulties and it was not entirely successful. It was eventually replaced by a more conventional line. The windmill on the right stood on part of the old 'Metal's' Track. It was used to pump water to the nearby cottages and to the fields for farming.

Below: Killiney Railway (Vico Road), *c.* 1900. The train is heading north from Bray. The rail journey from Bray to Dalkey along the edge of the sea is quite dramatic. Killiney Bay has often been compared to the Bay of Naples. The area has more than a liberal sprinkling of Italian names, Sorrento Park, Vico Road and so on. Killiney's railway station had been on Seafield Road but this proved inconvenient to the majority of residents and in 1882 the station was moved to its current location. Killiney Obelisk can be seen at the top of the hill.

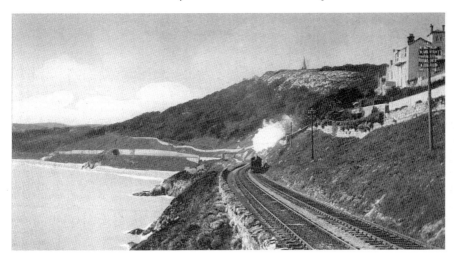

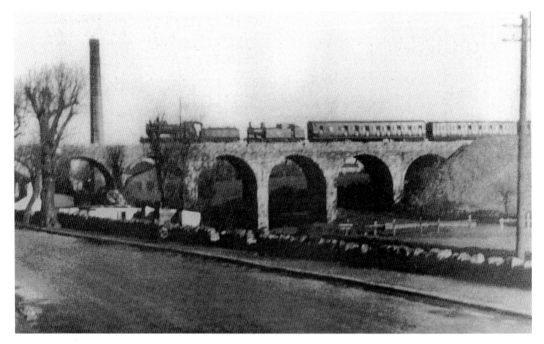

Milltown Viaduct, 1896. The Harcourt Street line opened fully in 1859 as an inland alternative to the coastal Dublin & Kingstown Railway. This line served Ranelagh, Milltown, Dundrum, Stillorgan, Foxrock, Carrickmines and Shankill joining the Bray line at Shanganagh Junction. The viaduct itself is a magnificent nine-arch limestone bridge over the River Dodder.

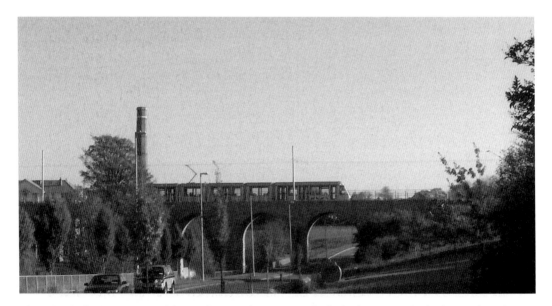

The Nine Arches is now part of the newly opened Luas Line. The high chimney in the background is of the old Dublin Laundry Company Ltd of Milltown.

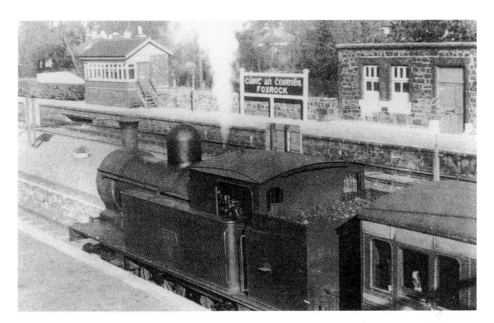

Foxrock Station, *c.* 1914. The Irish used in the station sign says 'Cúirt An Coirnéil' which is the Irish for Cornelscourt rather than Foxrock. Samuel Beckett set his radio-play 'All That Fall' in Foxrock Station. Born in 1906 his family home was on nearby Brighton Road. The station is also referred to in his second novel, 'Watt'. The twelve-mile Bray-Harcourt Street route took just over half-an-hour. So that fare-paying passengers did not have to endure any unpleasant smells it was forbidden to carry fresh fish on passenger trains. The line was closed in December 1958. The newly opened Luas line runs along the old line for much of its journey.

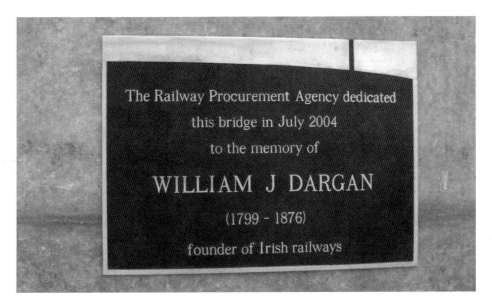

Plaque, Luas Bridge. The newly built Luas Bridge at Dundrum has been called after William Dargan, builder of the Dublin Kingstown Railway in 1834. The date on the plaque is incorrect. He died in 1867.

Dargan Bridge, Dundrum. William Dargan lived at Mount Anville within view of the new Luas Bridge that now bears his name. As well as being a railway contractor he was also a businessman, property developer and speculator. For a time he was also owner of the Royal Marine Hotel. He was a noted patron of the arts and there is a statue in his honour on the lawn outside the National Gallery of Ireland. In later life his health suffered after a severe fall from his horse and he lost his fortune. The Sisters of the Sacred Heart bought Mount Anville from him in 1865. When he died in 1867 he was virtually destitute. His house is now a school.

two

The
Harbour

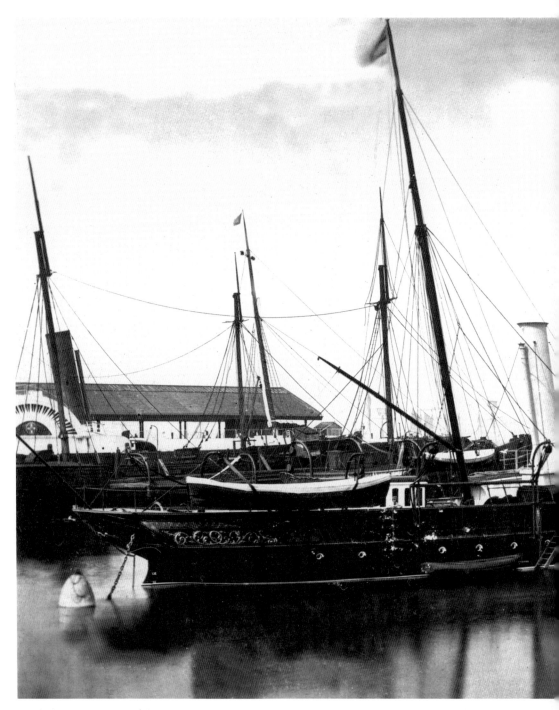

Kingstown Harbour, *c.* 1870. In his survey of Dublin Bay in 1800, Captain Bligh, who later became famous for his part in the 'Mutiny on The Bounty', reported that the pier at Dunleary 'has nothing to recommend it, being ill-adapted for its purpose'. It was generally agreed that a large harbour in Dublin Bay was required. Aware of this deficiency prominent locals lobbied for an 'Asylum Harbour'. A number of petitions were sent to the English parliament to this effect. Their efforts proved successful and a

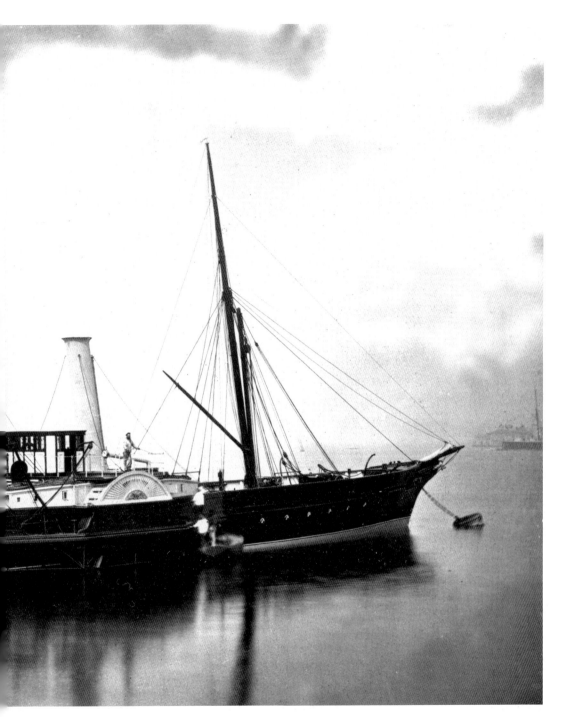

project for the construction of a new harbour was undertaken, starting in 1817 and finishing in 1842. It was a massive enterprise and when completed gave Kingstown one of the world's finest and safest artificial harbours of its time. The 'Princess Alexandra' was a paddle steamer in service as a tender with Irish Lights from 1863 up to 1904. It was sold to a Mr John Frame on 14th April 1904 for the grand sum of £1,110.

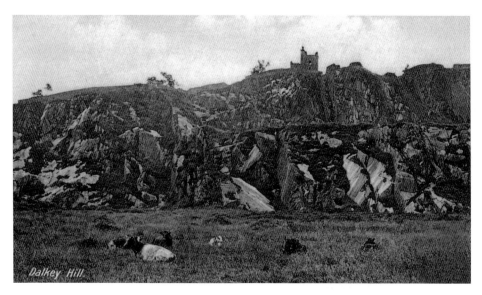

Dalkey Quarry, *c.* 1900. Most of the granite stone for the harbour was taken from Dalkey Quarry, though some was taken from Glasthule at the site of what is now the People's Park. A small funicular railway system enabled the descending full trucks to haul back up the empty ones. Over 1000 workers lived on Dalkey Commons while the work was in progress. As can be seen, once the work was finished the area around the quarry reverted to agricultural use.

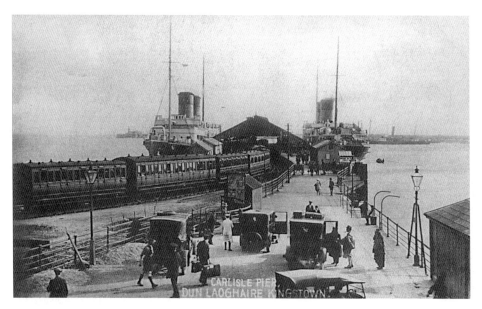

Mailboat, Carlisle Pier. Dun Laoghaire is 64 miles from Holyhead and has maintained a regular mailboat service for almost two hundred years. In 1826 the Kingstown-Liverpool Mail Packet route was established. A later Kingstown-Holyhead passage was added. It meant that Kingstown became the principal mail and passenger link between Dublin and England in the nineteenth century. As can be seen in this postcard from the 1920's there was always a flurry of activity when the mailboat arrived.

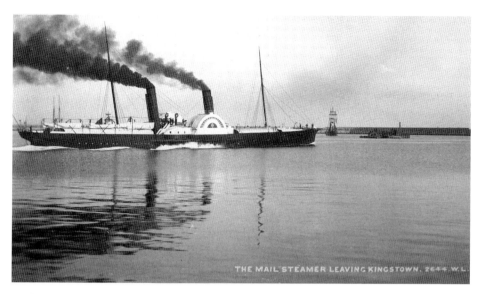

The mail steamer leaving Kingstown. 2644 W.L.

Mailboat Departing, *c.* 1900. With the completion of the harbour and the railway Kingstown had the latest and fastest means of transport at the time by land and by sea. Carlisle Pier where the mailboat docked also had its own rail line. At the time of the opening of the pier 3 and ¾ hours was the passage time of the crossing. London was eleven hours from Dublin.

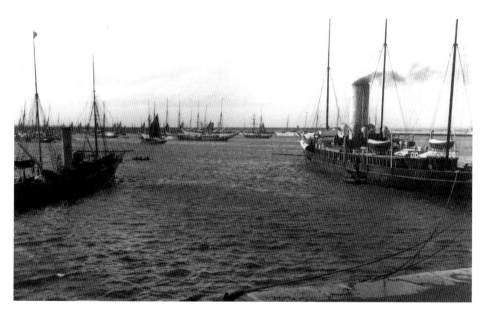

Kingstown Harbour, around 1900. In 1854 over 20,000 troops embarked from Kingstown, bound for the Crimea. Many of them did not return. It is reckoned that several thousand Irishmen died during the Crimean War. Kingstown always had a strong maritime tradition, not just the mailboat and the Royal Navy. Fishing, commercial shipping, and recreational yachting and boating were also important features of harbour activity.

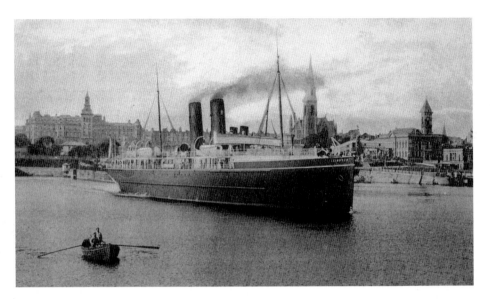

Above and below: Leinster Mailboat, *c.* 1910. In 1896 four screw-propelled ships, the *Leinster*, *Munster*, *Ulster* and *Connaught* were commissioned to replace the older and slower paddle mailboats. The average passage time of these new ships was just under three hours. This bears favourable comparison with the current timetable. The *Leinster*, *Munster*, *Ulster* and *Connaught* sailed regularly between Dun Laoghaire and Holyhead even during the First World War. They were obliged by their contract with the Post Office to maintain the service even with the threat of German U-Boats in the Irish Sea. In October 1918, just before the end of the war the *Leinster* was torpedoed 16 miles out from Kingstown. Over five hundred lives were lost. As this clipping from the Dublin Post of 1960 demonstrates, the human cost for the Dun Laoghaire area could still be felt nearly fifty years later.

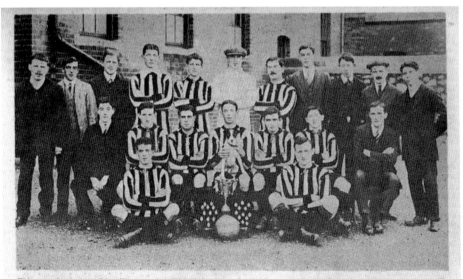

This was the famous Edenville team for 1911-1912. The death of one of its members, Con Hanney, of Glasthule (front row left) will recall to many its great wins. Many of the team perished when the Leinster sank. Following the the names of the team. Back row (from left): J. Whelan, A. Whiston, J. Weafer, P. Dempsey. Centre : M. Dixon, J. Doyle, W. Devitt, M. Hanney, F. Kehoe, J. Sharkey, and the Secretary, F. Sharkey. Front : C. Hanney and R. Waters.

Above: Harbour Constabulary Office, undated. Harbour constables were first appointed in 1817, they wore a blue uniform with red cuffs and capes and a glazed hat. This very small Constabulary Office was on Victoria Wharf and survived till the 1960s.

Below: Kingstown Harbour, *c.* 1900. The harbour was an impressive engineering achievement. There appears to be a body of policemen or soldiers marching in military order along the pier. The ships are decked out in celebration.

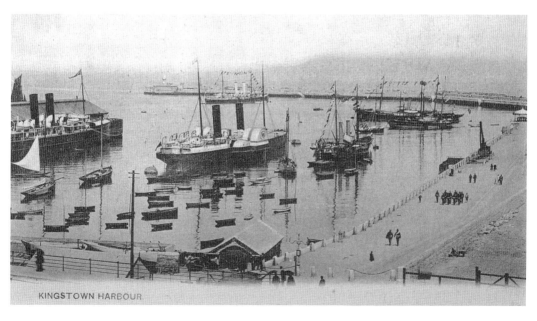

KINGSTOWN HARBOUR

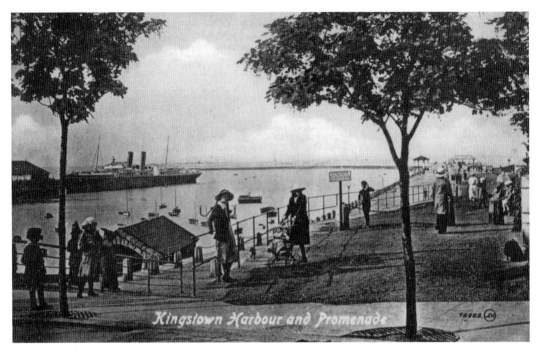

Above: East Pier, *c.* 1900. By the 1880s Kingstown's reputation as a resort, a seaport and a residential town was well established. The town had become a place where 'the belles and beaus of the Irish Metropolis' came to see and be seen. Walking the East Pier became a Kingstown tradition. The sign says 'Cycling is prohibited'.

Below: Kingstown Pier, *c.* 1910, with the Mariner's Church, Royal Marine Hotel, St Michael's Church and the Town Hall in the background. To the right of the bandstand, is the lifeboat house and slipway, built in 1901.

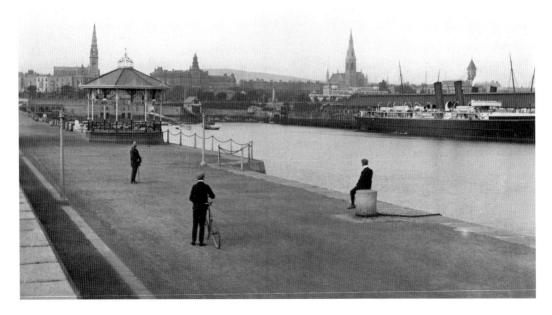

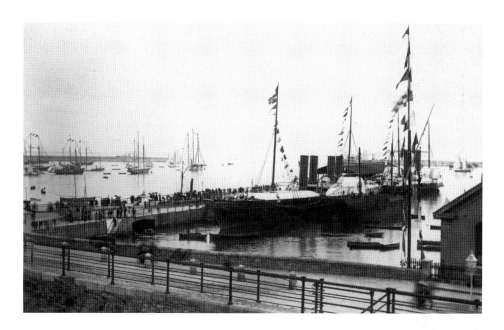

Above and below: Carlisle Pier, *c.* 1900. All the ships in the harbour are decked out in celebration. Many of the regattas were sponsored by the Dublin & Kingstown Railway Company. Recreational sailing was becoming more and more popular, as a spectator sport as well as a participatory one. Yachting attracted the upper classes. This, in turn helped draw crowds of visitors and spectators to the regattas. They were impressive social events, in particular the August Regattas. Houses would be rented out for the 'Season'. In July 1898 Guglielmo Marconi transmitted radio signals from a tug in Dublin Bay giving details of the progress of the Regatta races to his assistant at the Harbour Master's House (now known as Moran Park House). This could be said to be the world's first outside broadcast of a sporting event.

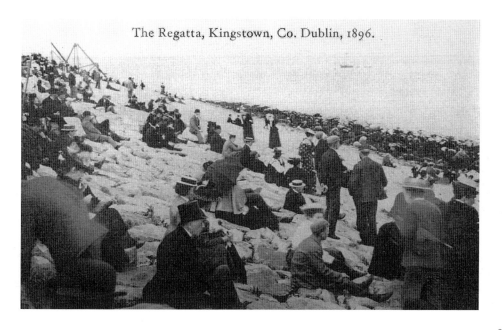

The Regatta, Kingstown, Co. Dublin, 1896.

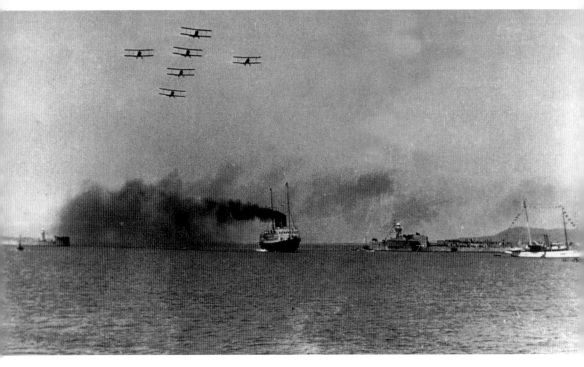

In June 1932 Dublin hosted the 31st Eucharistic Congress which was opened by Cardinal Legate Lorenzo Lauri. Six Irish Air Corps Avro 631's in cruciform formation escorted the Papal Legate on board the *S.S. Cambria* ferry into Dun Laoghaire Harbour on his way to the Congress.

Opposite above: This aerial view of Dun Laoghaire dates from 1968 and shows the harbour before the development of the marina and the new ferry terminal. In the bottom left corner the Salthill Hotel can be made out. The two smaller piers are the Coal Harbour and Trader's Wharf. The area to the left outside the harbour is known as the 'Gut' and is the site of a Sewerage Pumping Station. It is also an area popular with wind-surfers. The two activities may appear to be in conflict but they seem to happily co-exist.

Opposite below: Dun Laoghaire Harbour. This John Hinde postcard from the 1970s shows the modern day harbour. John Hinde's colourful and romanticised postcards of Ireland, all turf cutting and donkeys and children with red hair and freckles helped define Ireland's image as a tourist destination in the United States. John Hinde Limited was based on the Old Bray Road in Cabinteely till the 1970s.

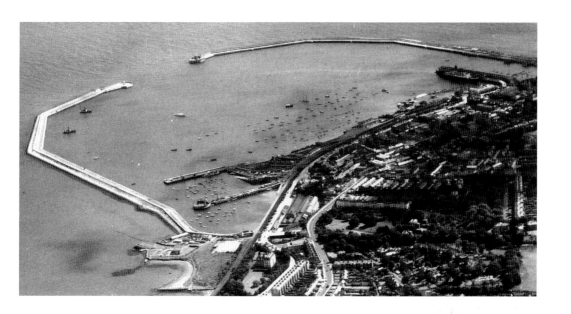

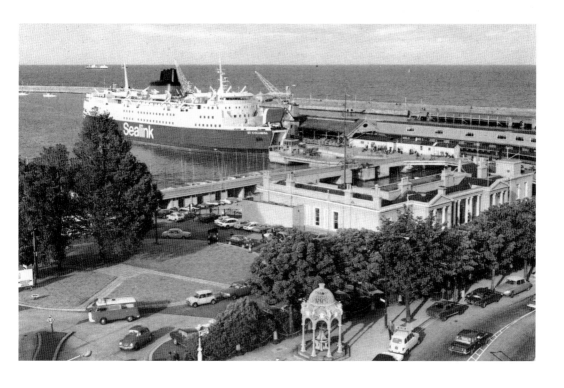

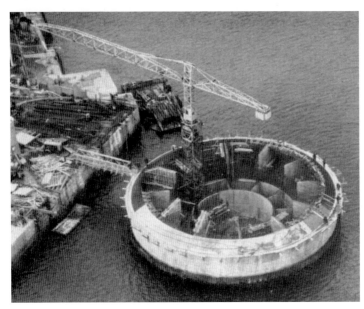

Work started on the building of a new lighthouse for the Kish in Dun Laoghaire Harbour in 1963. This undertaking brought much-needed employment to the Borough. According to one account the workers and contractors were enthusiastic patrons of the local hostelries, The Purty Kitchen and The Cumberland in particular. On a particularly memorable occasion a round of drinks for 72 people was called for in Walter's Pub.

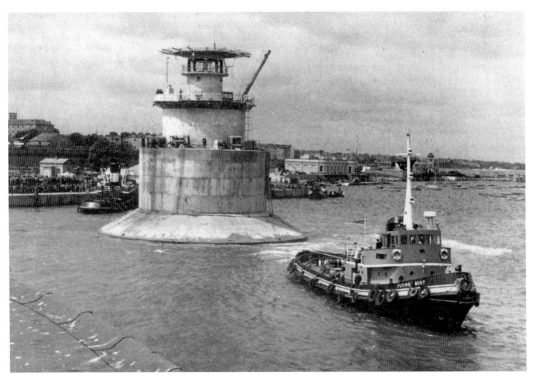

The Tower was built in the shelter of the Coal Harbour and then moved to a second berth by the East Pier. There was enormous public interest and crowds flocked to see this unusual undertaking. In the picture above the lighthouse is being towed by the *Flying Mist*. By June 1965 the building was completed and the entire structure was towed by two tugs to its place on the Kish Bank. It weighed over seven thousand tons. By November 1965 it was fixed in position.

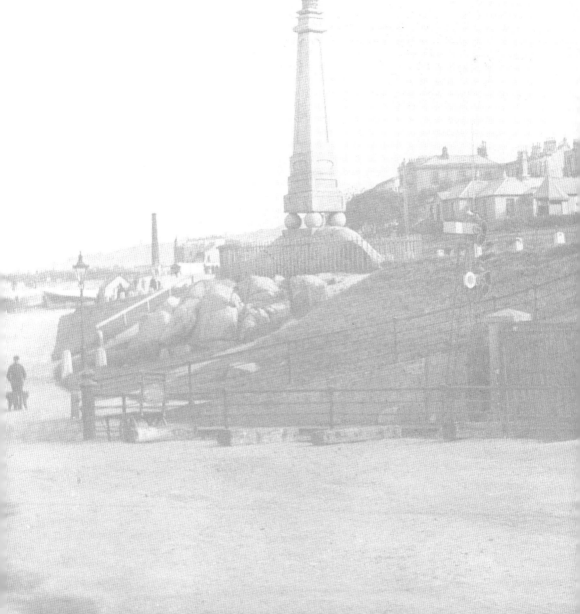

three

Kingstown

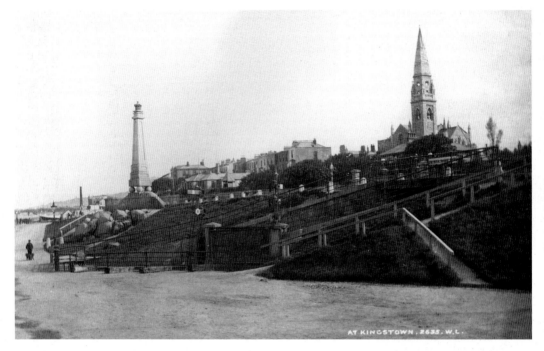

Above and below: The George IV Obelisk was erected in 1823 to commemorate both the visit of King George IV in 1821 and the laying of the first stone of the harbour in 1817. The 1821 visit was slightly shambolic. Despite the preparations at Dunleary for his arrival, King George disembarked at Howth instead. A month later he departed from Dunleary. In the photograph, a sign for the Royal Marine Hotel can just be made out through the railings of the bridge. Following the visit in 1821 it was decided to go ahead with the name change to Kingstown and the erection of the monument. As William Thackeray commented 'After that glorious event Dunleary disdained to be Dunleary any longer and became Kingstown henceforth and forever'. In the background can be seen the railway station and the Town Hall.

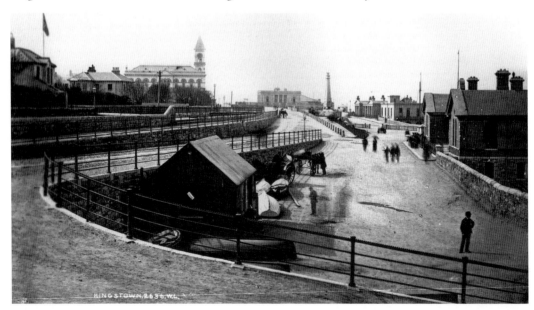

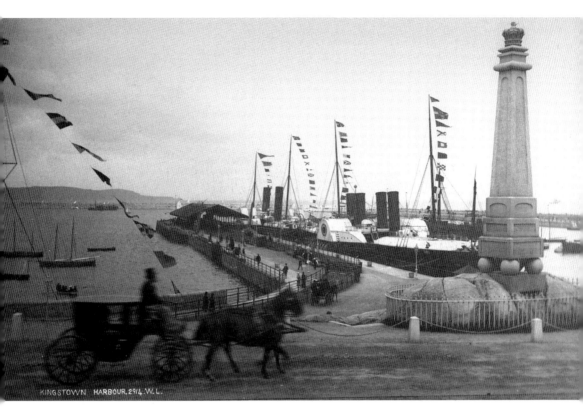

Obelisk and Harbour, *c.* 1900. According to William Thackeray who was no fan of George IV, the monument was 'a hideous Obelisk, stuck on four fat balls and surmounted with a crown on a cushion'. Nevertheless the Royal Visits drew attention to the Harbour and the Town. The Visits of the Royal Yacht to Kingstown in 1900, 1903, 1904 and 1911 provided pomp and spectacle for the town, as did the arrival of the Atlantic Fleet in 1906 and 1907.

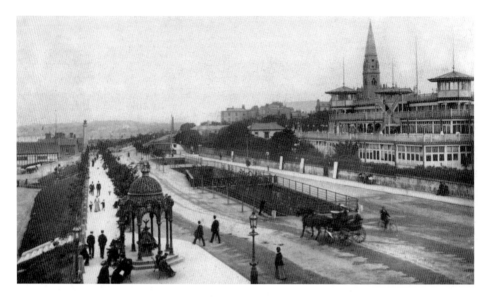

Victoria Monument, *c.* 1900. An elaborate iron structure, the Victoria Fountain was erected to commemorate Queen Victoria's last visit to Ireland in 1900. Originally it was connected to the water supply and had iron cups attached from which people could drink if they so desired. Above we see a busy street scene with the Pavilion Gardens to the right, the cyclist and the horse drawn carriage in the centre seem to have had a near miss.

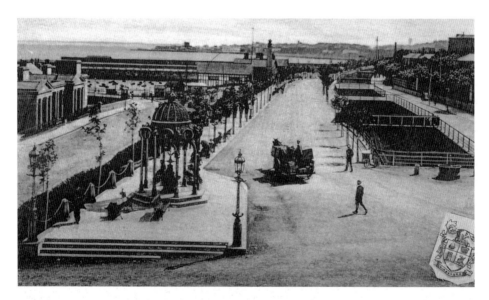

Victoria Fountain, *c.* 1900. Queen Victoria had passed through the harbour on numerous occasions, in 1849, 1853, 1861 and 1900. As she herself remarked in her diary after her first visit 'it is a splendid harbour and was full of ships of all kinds'. The road was originally called Harbour Road but was changed to Queen's Road in honour of her 1900 visit. Despite some attempts in later years to change this road's name, it is still known as Queen's Road. The canopy of the monument was vandalised in 1981 but has since been completely restored.

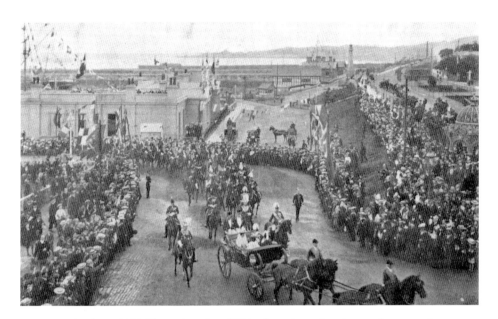

Kingstown Harbour, 1903. The various Royal Visits throughout the nineteenth century, in conjunction with the name change from Dunleary to Kingstown helped focus interest on the rapidly developing town. The bunting, the naval display and the military pomp, all became regular features of the social scene in Kingstown. Both the Victoria Fountain and the George Obelisk can be seen in this image.

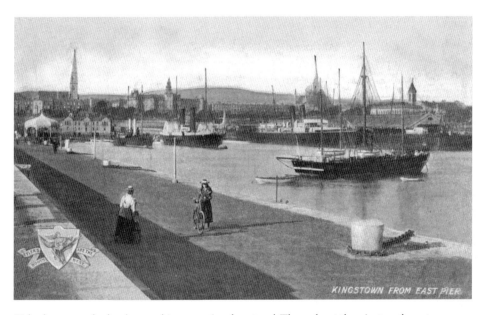

'Tyler boots are the best' states this promotional postcard. Throughout the nineteenth century the population of Kingstown was growing steadily, in 1831 it was 5,736, in 1841, 7,500 and by 1851, 10,500. By 1926 it had risen to 17,219. In the background the Mariner's Church, the Royal Marine Hotel, St Michael's Church and the Town Hall can be seen. Scaffolding around the spire of St Michael's Church can just be made out.

Above: Upper Georges Street, Kingstown, *c.* 1900. A long straight, military road connected the Martello Towers at Dunleary and Glasthule. This road became the main street in Kingstown and was called after King George IV. In 1838 the Town Commissioner's recommended that the street be divided in two, Upper and Lower. The old Courthouse built in 1900 is on the left on the site of what is now the post office.

Below: Lower Georges Street, Dun Laoghaire, *c.* 1930. In the mid-nineteenth century the naming of the streets in Kingstown followed a royalist, Anglo-centric trend. Cumberland, Carlisle, Sussex, Northumberland, Angelsea, York, Wellington as well as Victoria were among the names used. In later years there were a number of attempts to change Georges Street's name, to Pearse Street, to Casement Street, to Moran Street and even to O'Growney Street, but Georges Street it remains to this day.

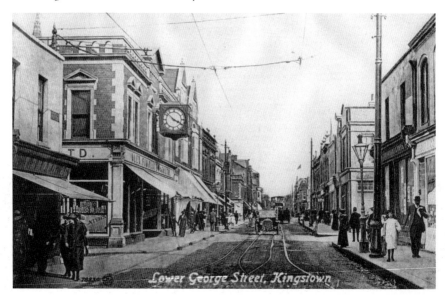

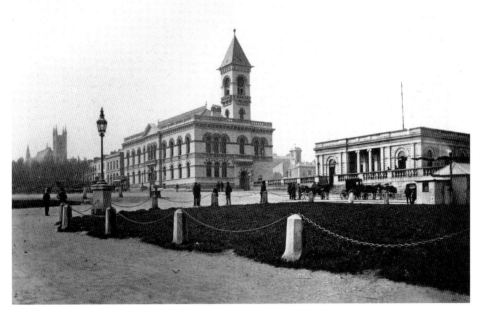

Above and below: These two pictures show the rapid development of Marine Road which was then known as Royal Marine Road over a short number of years. The image above was taken around 1896. The square tower of the older version of St Michael's Church is in the background. The Town Hall was the last of Kingstown's large public buildings to be completed in 1880, at a cost of £16,000. Designed by John L. Robinson, who was also responsible for St Michael's Hospital, the People's Park and the Gothic spire of St Michael's Church. The Pavilion site to the left is still empty. In the picture below taken just a few years later the newly opened Pavilion is to the left and the spire of the rebuilt St Michael's Church is in the background. Cabmen are waiting at the side of the railway station.

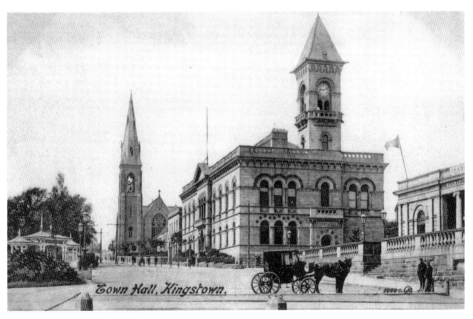

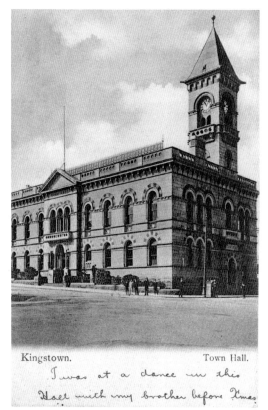

Kingstown. Town Hall.

Twas at a dance in this Hall with my brother before Xmas

Left: Kingstown Town Hall, *c.* 1903. The Town Hall also served as a Courthouse and as the postcard shows a venue for dances. Concerts were also held there.

Below: Marine Road, *c.* 1895. Marine Road was then known as Royal Marine Road. A horse drawn tram can just be made out behind the crack in the print. The Town Hall has railings around it. Its architect John L. Robinson also designed the Post Office, which is the building to the right of the Town Hall. The two buildings were recently combined to form the new County Hall for Dun Laoghaire-Rathdown.

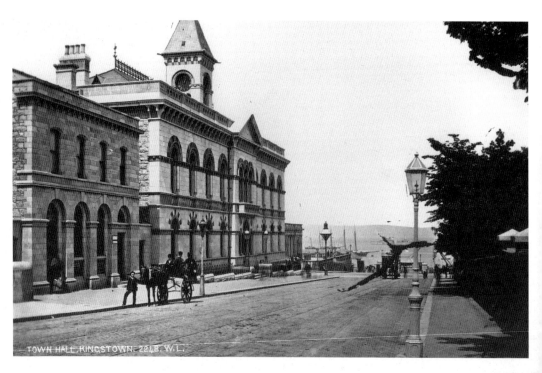

TOWN HALL, KINGSTOWN. 2248. W.L.

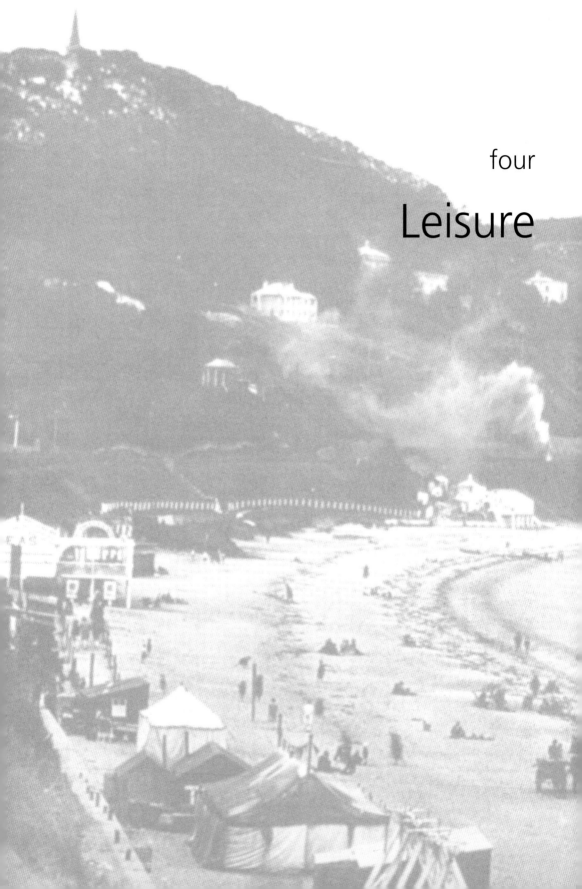

four

Leisure

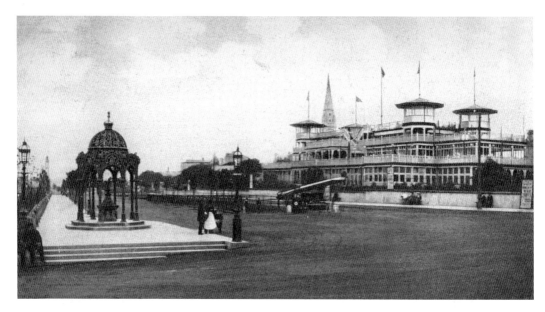

Kingstown Promenade. By the middle of the nineteenth century Kingstown had become a 'place of fashionable resort'. The combination of the seaside, parks and promenades made it an ideal Victorian holiday destination.

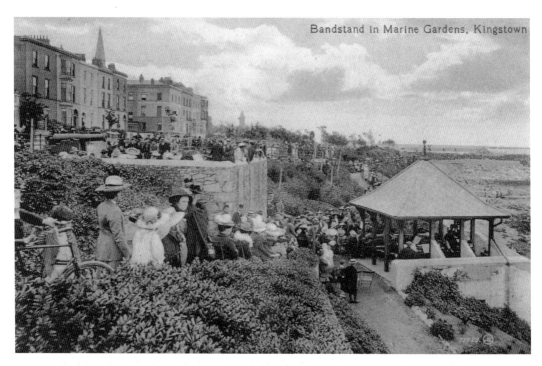

Bandstand in Marine Gardens, Kingstown

Bandstand Kingstown, *c.* 1910. There were regular concerts at the weekends and in the evenings in summer. Bandstands on the pier, in the Pavilion Gardens and in the People's Park were among the many venues. Note the cannon to the top left. The bandstand is still there; the cannon is no longer there.

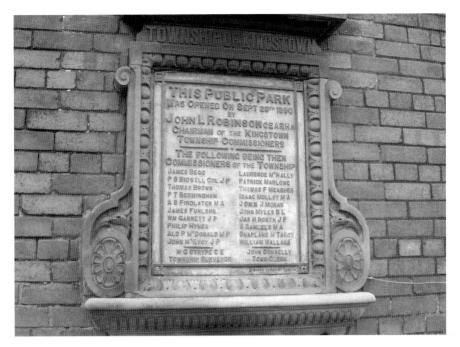

People's Park. The park was opened in 1890. Part of the grounds had been the location of Glasthule Martello Tower. There had also been a quarry on the site. John L. Robinson, the architect who had designed the Town Hall also laid out the plans for the Park. As the inscription on the plaque shows, he was also Chairman of Kingstown Township Commissioners at the time, an unusual arrangement by todays standards.

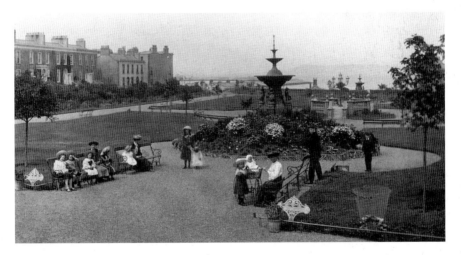

People's Park Kingstown, *c.* 1900. The Sun Alliance Foundry of Glasgow, who were also the makers of the Victoria Monument on the sea front, cast the two impressive iron fountains in 1895. Note that the fountain in the photograph has been covered over with flowerbeds, possibly because the original water pipes were too small and there was insufficient water pressure. Everybody in the photograph from the infant in the pram up is wearing a head covering though whether that is a due to Victorian convention or the weather conditions is unclear.

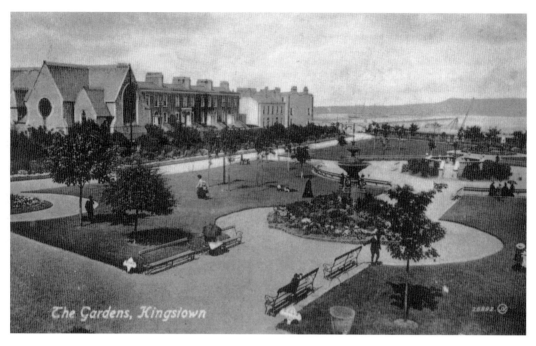

The Gardens, Kingstown

People's Park, *c.* 1900. In this image the fountains are not in use. However in modern times both of the fountains have been restored and are back in working order. A farmer's market is now held in the People's Park every Sunday.

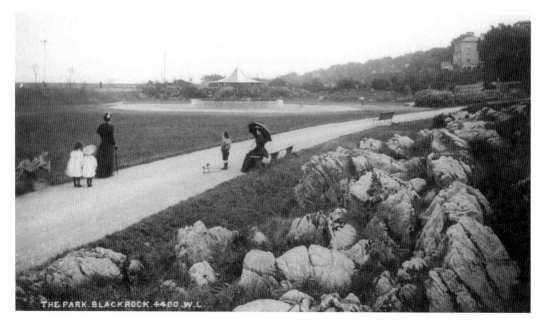

THE PARK, BLACKROCK 4400 W.L.

People's Park Blackrock, *c.* 1900. Originally named Blackrock Park but now known as Blackrock People's Park it was built in the 1870s, on what had been the Vauxhall estate, laid out around a hill. An artificial lake was created. The bandstand can be seen in the background.

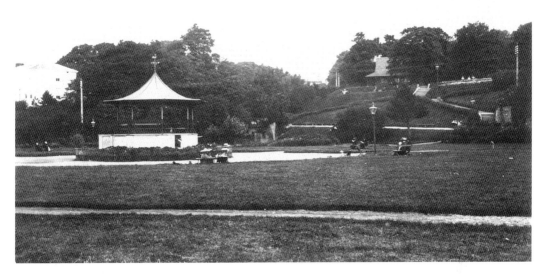

Blackrock Park, around 1900. Part of the land for the park had been reclaimed from the sea when the Dublin Kingstown Railway was built in 1834. The Township of Blackrock Regulations 1881 for the Park ran to six pages of 32 bye-laws. Bye-law number five stated that 'No Groom or Horsebreaker shall exercise or train any horse in any part of the Park.' Bye-law number 19 stated that 'No person shall capture any bird, nor take or disturb any bird's nest'

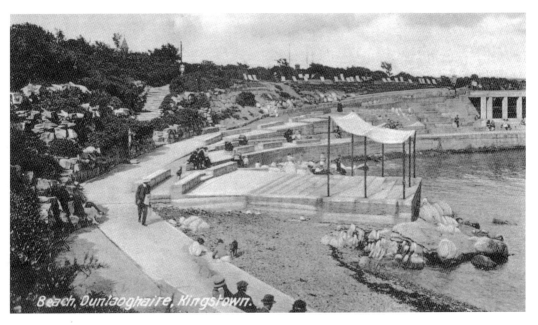

Dun Laoghaire Beach. This 'beach' was at the back of the East Pier and was very pebbly. The white rectangles in the background are unused deck chairs waiting to be occupied. The sky above looks distinctly unpromising.

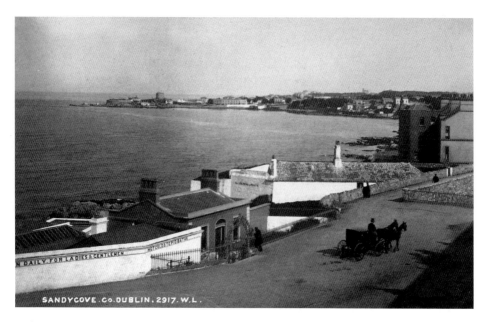

SANDYCOVE.Co.DUBLIN.2917.W.L.

Baths, Kingstown, *c.* 1890. In the 1840s John Crosthwaite built the Royal Victoria Baths which offered both open sea bathing and as the sign states 'hot cold or tepid baths' as an option. These could be of salt or fresh water. Kingstown Urban District Council bought the baths in 1896 and they renovated them between 1905 and 1911.

A letter was read from Mr. C. J. Fergusson regarding the rescue of Miss Pelly, of Harcourt-street, by his son, H. C. Fergusson, at the Royal Victoria Baths on Tuesday, 3rd of September, 1901.

Moved by Councillor Colonel Beamish ;
Seconded by Councillor M'Cullagh—

"That the thanks of this Council be conveyed to Captain H. C. Fergusson of the Highland Light Infantry, for having on the morning of the 3rd inst. gallantly rescued from the danger of drowning Miss Pelly, of Dublin, who was in great danger of loosing her life at the Royal Victoria Baths, Kingstown, and that a Report of the circumstance be forwarded to the Royal Humane Society, so that his gallant conduct may receive suitable recognition."

As these minutes of a Kingstown Urban District Council meeting from 16 September 1901 show the baths could be a dangerous place. Luckily, gallant Captain Fergusson was on hand to rescue Miss Pelly from peril.

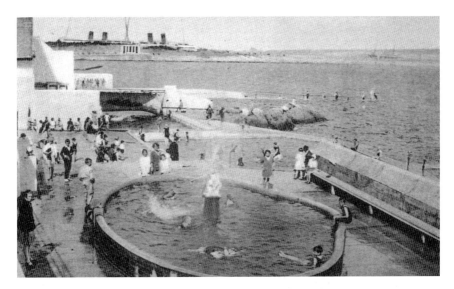

Baths, Dun Laoghaire, *c.* 1930. There had been public outcry that the building of the railway had cut off free access to the seashore. The Railway Company offered concessions to those who bought subscription tickets; 'Subscribers have the privilege of bathing free of charge at any of the Company's Cold Sea Baths, on week days only'. As the result of political pressure free public baths were eventually built. The provision of Public Bathing places was seen as being a health measure more than as a social amenity at the time.

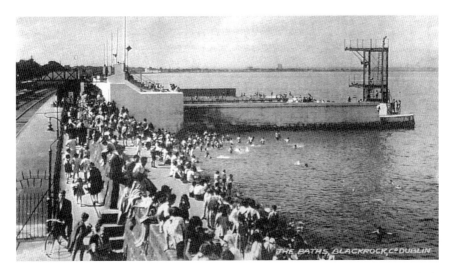

Blackrock Baths, *c.* 1930. In 1888 a private company offered to run the baths on behalf of the railway company. The Blackrock Town Commissioners eventually took them over. In this image from the 1930s it is obvious how popular they were. Note also the high diving boards, with a 5 metre, a 3 metre and a springboard. The Tailteann Games swimming events were held there. The Tailteann Games were an ancient festival of sportsmanship revived by the GAA in the 1920s and '30s. Eddie Heron, Ireland's first and perhaps only diving superstar gave exhibitions at the Sandycove Galas, which were held at Blackrock Baths. They attracted massive crowds.

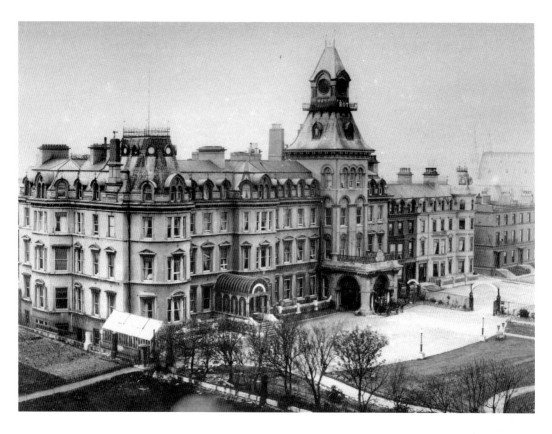

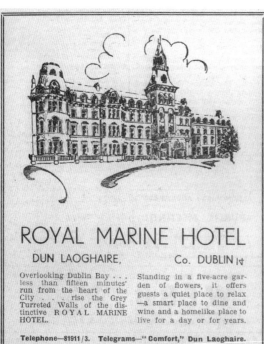

ROYAL MARINE HOTEL

DUN LAOGHAIRE, Co. DUBLIN

Overlooking Dublin Bay . . . less than fifteen minutes' run from the heart of the City . . . rise the Grey Turreted Walls of the distinctive R O Y A L MARINE HOTEL.

Standing in a five-acre garden of flowers, it offers guests a quiet place to relax —a smart place to dine and wine and a homelike place to live for a day or for years.

Telephone—81911/3. Telegrams—" Comfort," Dun Laoghaire.

Above and left: Royal Marine Hotel, *c.* 1900. Originally there had been a hotel known as Hayes's on the site. William Dargan, builder of the Dublin Kingstown railway, developed the Royal Marine Hotel. His company went broke before completing the huge project and a slightly more modest building was erected in its place. The part to the right of this picture was the remnant of the old hotel, which accounts for the slightly lopsided look of the building. The advertisement below dates from 1948. It offers "a homelike place to live for a day … or for years."

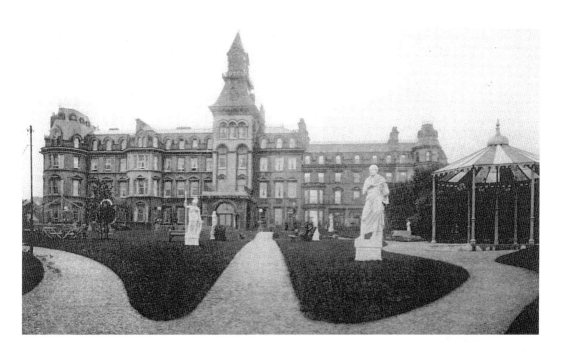

Above and below: Originally the Royal Marine Hotel had extensive grounds 'beautifully ornamented with walks, statues, flower knots, sparkling fountains …' In today's hotel the gardens remain. In the course of one of its many renovations, the old elaborate roof was removed and replaced by a plain flat one.

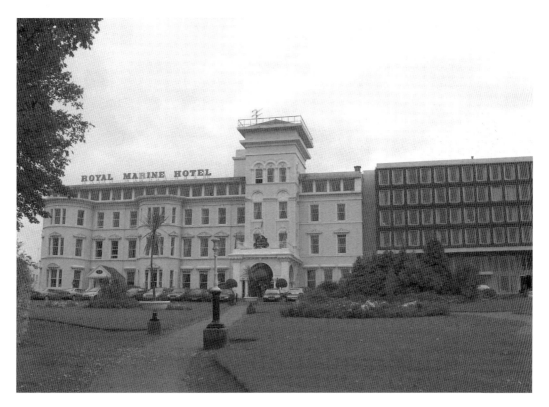

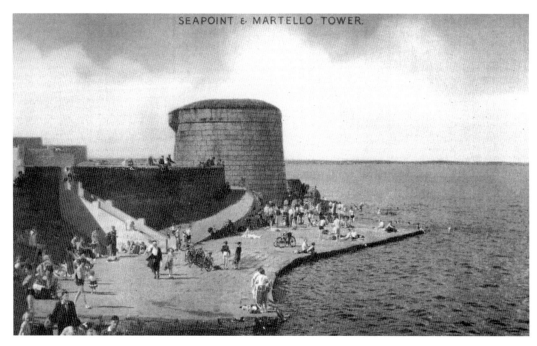

Seapoint Martello Tower was one of 74 towers built along the coastline of Ireland at the beginning of the nineteenth century to guard against a possible French invasion. Many had a battery or fort attached.

Sandycove Martello Tower. The first scene in James Joyce's 'Ulysses' takes place on the roof of Sandycove Martello Tower. Oliver St John Gogarty, "stately plump, Buck Mulligan" in the novel, was renting the tower and had invited Joyce to stay there for free in return for doing the housework but the two men soon fell out. James Joyce actually stayed there for less than a week. It now houses a Joyce Museum.

Marine Parade, *c.* 1930. The road extends along the seafront from Dun Laoghaire to Sandycove. It was constructed in 1922. In this postcard the road looks in very poor condition and perhaps it is for that reason that the car is travelling down the middle of the road.

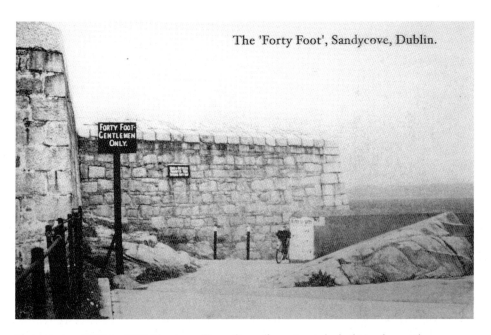

Forty-Foot, *c.* 1900. In 1863 Kingstown Town Council constructed a bathing place at the Forty-Foot in front of the battery. The 'Gentlemen's Bathing Place' run by Sandycove Bathers' Association which was officially formed in 1880, to improve the location: at the time, 'whilst it was no easy matter for bathers get into the water, it was a far harder one for them to get out'. The Association is still in existence and is still supported by voluntary contributions. The theories of how ir got its name are many and varied

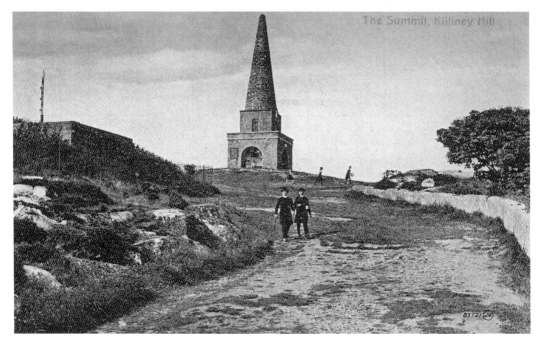

Killiney Hill, *c*.1910. Two religious gentlemen, from their attire, are strolling down from the Obelisk. A local landlord, Lord Malpas, had it built as a form of famine relief work-scheme, as the inscription states, 'the last year being hard with the poor'. It was erected in 1742.

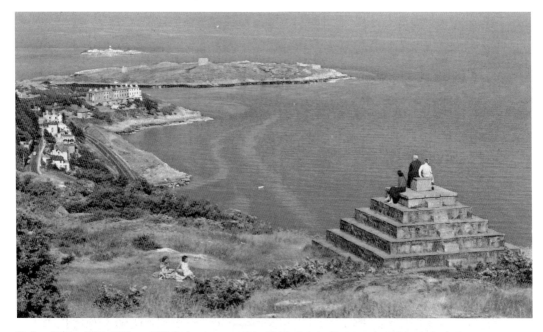

Dalkey Hill, *c*. 1970. Killiney Hill Park was opened in 1887. Originally named as Victoria Park, it was enlarged in the late 1930s with the purchase of Dalkey Hill. The Wishing Stone was built in the 1850s. Legend has it that if you walk clockwise around all the different levels, your wish would be granted.

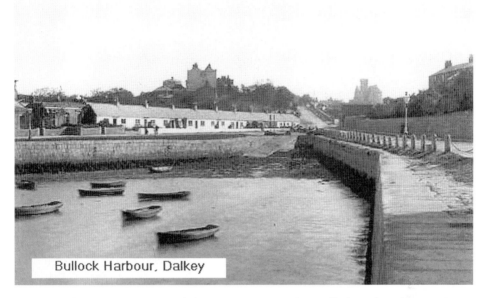

Bullock Harbour, Dalkey

Bullock Harbour, *c.* 1910. Captain Bligh in 1800 commented on Bullock Harbour; 'this is a dry harbour … to which small vessels come to load with stones'. The houses in the background are known as the Pilot's Cottages. Mainly hobblers occupied them. 'Hobblers' was the name given to men who used to row out to the ships. Unusually hobblers were reputed to row their boats standing up. It was a hazardous occupation. Just three of the cottages are now left.

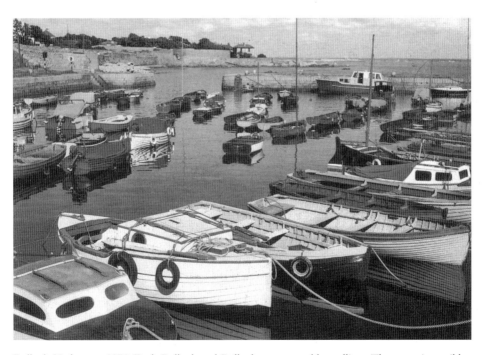

Bulloch Harbour, *c.* 1970. Both Bulloch and Bullock are acceptable spellings. The name is possibly Scandinavian in origin. The harbour is now mainly used for recreational purposes.

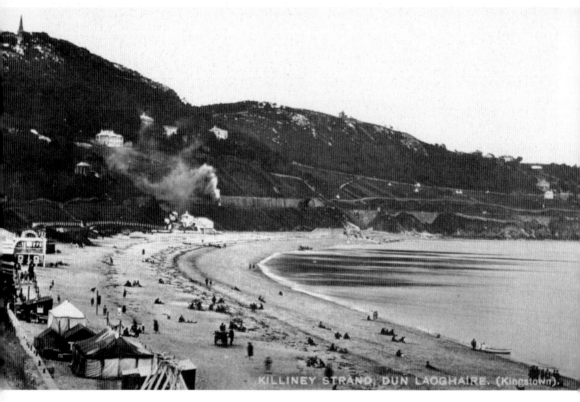

Killiney Beach, *c.* 1900. Killiney was popular as a bathing place as early as the eighteenth century and the coming of the railway made it much more accessible to the residents of Dublin. In this postcard the steam train can be seen approaching Killiney Station. The White Cottage, which can be seen in the background, along the shore was a tea-room where dances would also be held, in the open-air on the beach if the weather permitted. Killiney has many famous residents, including Bono of U2.

Opposite above: Glencullen Tug of War Team, 1892. The team display a cup. From left to right, back row: Phil Flanagan, Ned O'Neill, Bill Doyle, Willie Carroll, Tom O'Toole, and Tom Messitt. Front row: Martin Mitchell, Christie O'Toole, Tom Farrell, Jem Kenna, Johnny Fox, Pat O'Neill, Jem Doyle. The two O'Tooles in the photograph have a family resemblance, as do the two O'Neills. As can be seen a tug of war rope lies at their feet.

Opposite below: The Workmen's Club in Dun Laoghaire was built to provide recreational facilities and indoor sports for its members. Initially it was founded by Professor W.F. Barret as a Temperance Club, a place where workingmen could meet and play billiards or read the newspaper – without being tempted by the demon drink. This picture is from the *Dun Laoghaire Borough Times* a short lived local newspaper, it dates from the late 1940s.

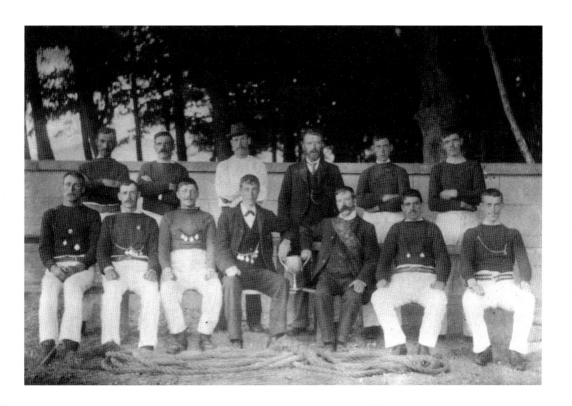

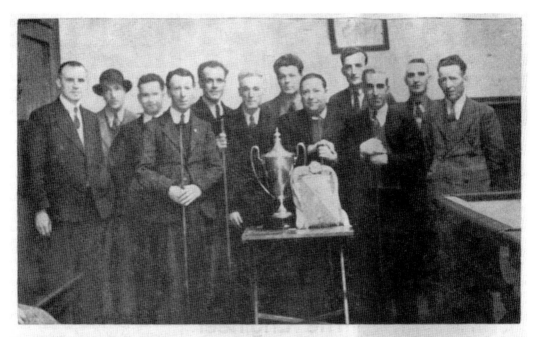

Workmen's Club Billiards Team, "City and County" Champions.—Left to right: E. Carroll (Hon. Secretary), M. Kelly, J. Durning (Committee), Paddy Archbold, T. Kelly, J. Massey (Club Chairman), C. Byrne, Peter Archbold, E. Ryan, M. Fogarty, O. Coyle (non-playing Captain) and J. Moran.

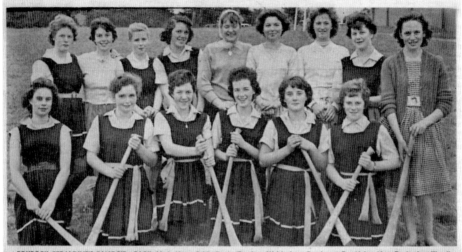

FOXROCK GERALDINE'S CAMOGIE. BACK: Marie Hayes, Bridie Doyle, (Rosaleen Walsh, Joan Geoghegan, Ena Nolan, Mary Doyle, Ann Kinsella, Nuala Leonard, Bernadette Murphy. FRONT: Ann Flood, Ronnie Moloney, Pat Leonard, June Doyle, Eileen O'Toole, Noeleen Brack (Captt.:n).

Above and below: Foxrock is not often strongly associated with Gaelic Games but it can lay claim to being the home of one of the oldest clubs in Dublin. The Foxrock Geraldines club was established in 1886 and is still in existence. Their grounds are located close to Cornelscourt. These two evocative newspaper photos from the *Dublin Post* date from September 1960.

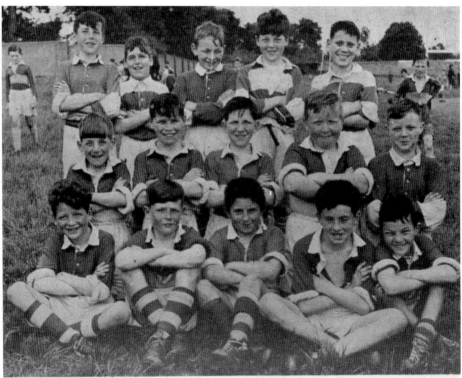

FOXROCK GERALDINES (Under 12)—BACK ROW (l. to r.): B. Cruise, A. Hynes, J. Devlin, D. Lahy, D. McCauley. MIDDLE ROW: J. Deegan, T. Gibbons, D. Kinsella, T. Quinn, B. Maguire, D. Keogh. FRONT ROW: D. Kelly, S. Gibbons, P. J. Kelly (capt.), F. Deegan, P. Lenehan.

five

The Pavilion

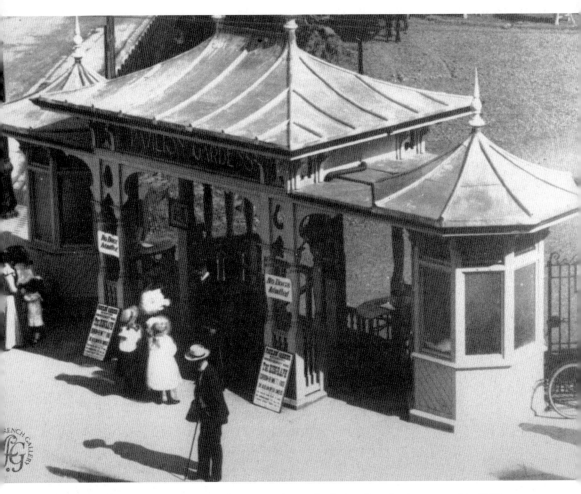

Pavilion Entrance, *c.* 1904. Laid out on four acres of grounds, the Pavilion Gardens opened in 1903 opposite Kingstown Railway Station. The building itself was an elaborate ornate structure like an oversize conservatory, all glass and wood, with promenades, ladies' and gentleman's reading-rooms, a smoking-room, a roof-top garden, tea-rooms, a concert hall and a roller skating rink. On the four-acre site there were also flower gardens, a waterfall, bandstands and tennis courts.

Opposite: Pavilion Bandstand, *c.* 1903. From their general appearance the umbrellas in this image were to keep off the rain rather than sun. The Victoria Fountain can be seen in the mid-distance with horse drawn cabs waiting for customers, the equivalent of a modern day taxi rank. There were a number of cabmen's shelters on Marine Road and Queen's Road.

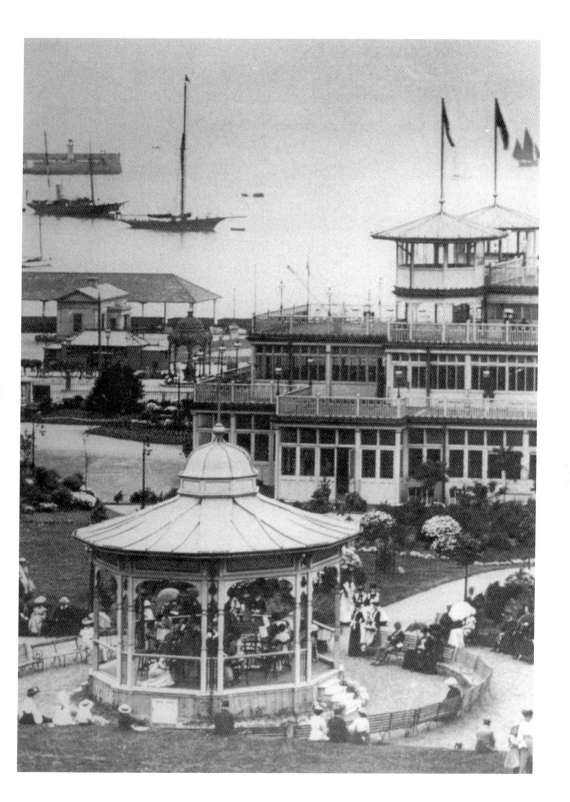

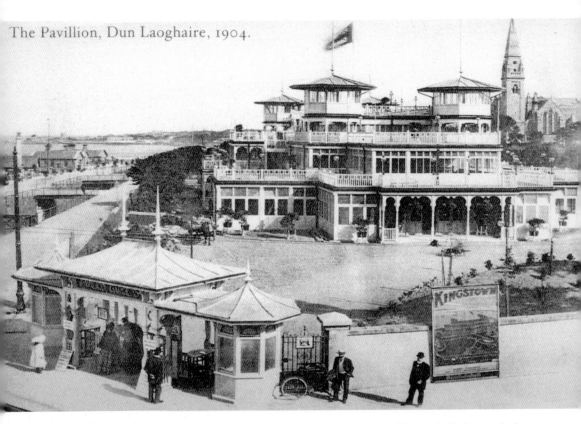

Pavilion Entrance, *c.* 1903. Events such as concerts, dances, variety shows and firework displays took place on its grounds. In 1906 Kingstown entertained the Royal Navy's Atlantic Fleet. A temporary covered bridge was constructed across Marine Road from the Pavilion to the Town Hall. Note that one of the signs on the entrance states 'No Dogs Allowed'. The title of the postcard is misspelled.

Opposite above: In this genteel game of mixed doubles from around 1903, the players have been painted onto the image; cameras of the time couldn't cope with their rapid movement.

Opposite below: The central hall of the Pavilion around 1903 was capable of holding 1000 seats. It was also used as a skating rink. The renowned Irish tenor Count John McCormack performed there on 31 August 1908, reserved seats cost four shillings, unreserved seats two shillings and it was one shilling at the door.

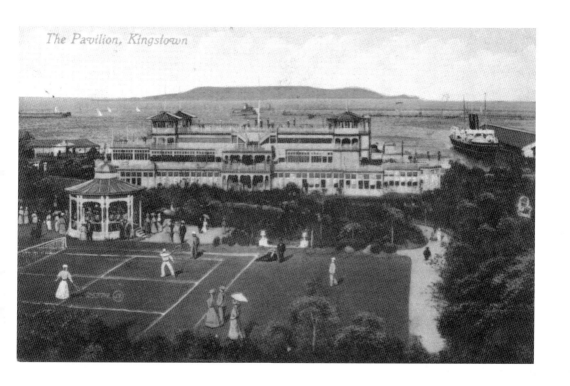

The Pavilion, Kingstown

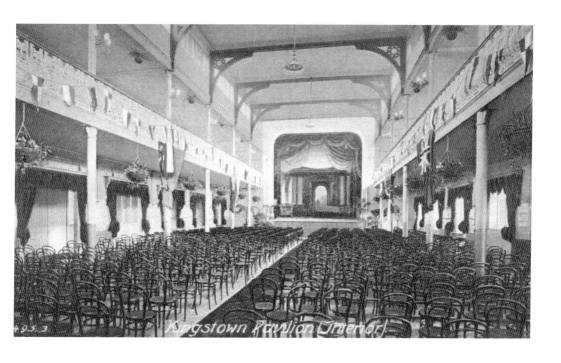

Kingstown Pavilion (Interior)

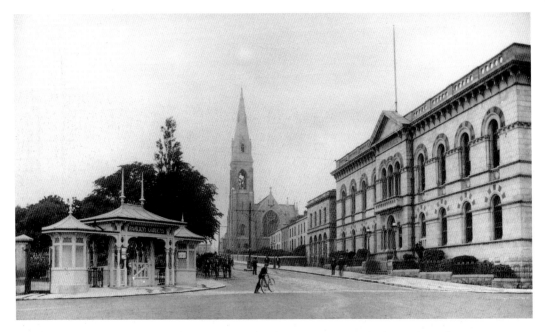

Marine Road, *c.* 1903. A row of horse drawn cabs can be seen waiting outside the Pavilion. There was a Cabman's Shelter just to the left of the entrance to the gardens which survived till the 1990s. The Town Hall to the right has railings in front of it that are no longer there.

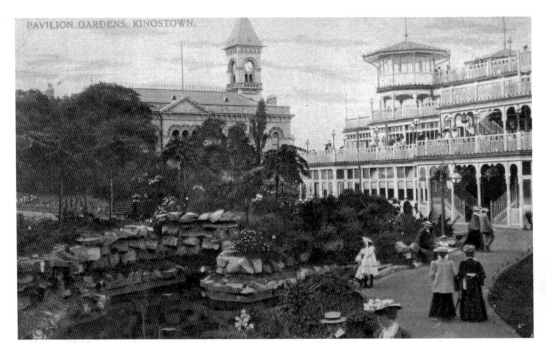

This view of the Pavilion Gardens with the Town Hall looming in the background gives an idea of its elegant charm at the beginning of the twentieth century. The fountains, the gardens and walkways made it a graceful and tranquil location for Edwardian ladies and gentlemen to take their leisure.

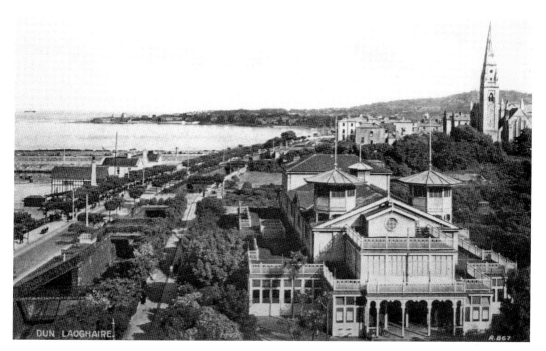

Pavilion View, *c.* 1910. On 13 November 1915, the Pavilion was consumed by fire despite the best efforts of the Kingstown Fire Brigade, assisted by Pembroke and Dublin Fire Brigades. Water was pumped from the harbour but their labours were in vain. The building was largely made of timber and glass. The picturesque turrets collapsed. Only the skeleton of the structure pictured above remained.

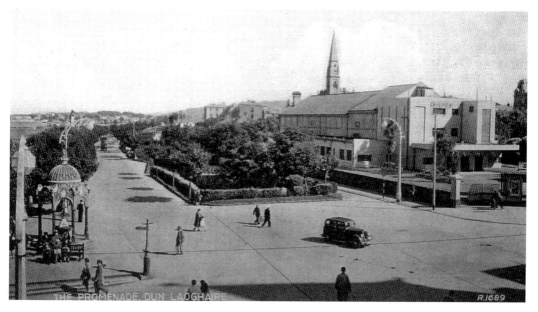

Eventually a cinema, known as the Pavilion Picture Theatre was built on the site. It had a capacity of 850 seats. Films had been shown occasionally in the original Pavilion.

a log

Hugh Leonard

suade us to brave the nor'easterlies.

My first date ever was with Ita Byrne, and I took her to the Pavilion. She wore crocheted gloves like lace mittens, from which her fingers poked pinkly out, and I can remember that she headed, considerate girl that she was, straight for the oneshilling window of the box office. With a gesture worthy of Diamond Jim Brady, I steered her grandly towards the one-and-fourpennies. Even then, I knew how to show a girl a good time.

rejoiced in the nickname of "Abie" because his middle initials were "A.B.". This — and I own up to being the instigator — led to his unfortunate waitresses, good girls all, being known as "Abie's Irish Pros".

For many years now the place has been a sad ruin, awaiting the decency of obliteration. Rather than be pulled down, stone by stone, it should perhaps have been blown up and turned instantly into a memory, like the picture house in *Cinema Paradiso*. Some say there is to be a skating rink on the site,

Noted Irish author and playwright Hugh Leonard, a native of Dalkey has fond reminiscences of the Pavilion. It was there that he went on his first date. It was with a Miss Ita Byrne and he took her to the one-and-four penny seats.

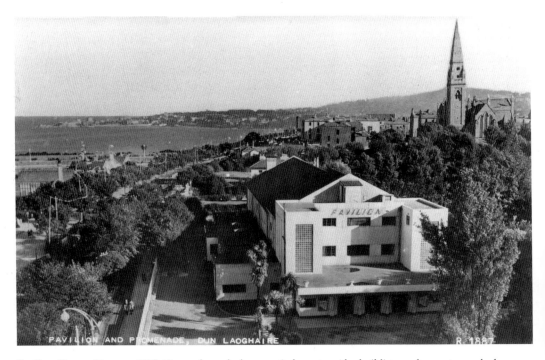

Pavilion Picture House, *c.* 1950. Down through the twentieth century the building underwent a gradual decline. In 1939 it was renovated and replaced by a less elegant concrete structure. Yet another fire occurred on 10 November 1940. With each fire the style of the structure deteriorated.

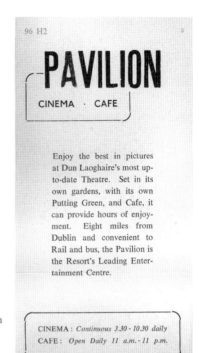

PAVILION
CINEMA · CAFE

Enjoy the best in pictures at Dun Laoghaire's most up-to-date Theatre. Set in its own gardens, with its own Putting Green, and Cafe, it can provide hours of enjoyment. Eight miles from Dublin and convenient to Rail and bus, the Pavilion is the Resort's Leading Entertainment Centre.

CINEMA : *Continuous 3.30 - 10.30 daily*
CAFE : *Open Daily 11 a.m. - 11 p.m.*

From 1953 this advertisement states that there was a café and putting green on the premises. The putting green was on the grounds of the cinema and was quite large. In 1974 the Pavilion Cinema closed. It opened intermittently for live shows and theatre and the occasional movie. The building also housed a ballet company for a short time.

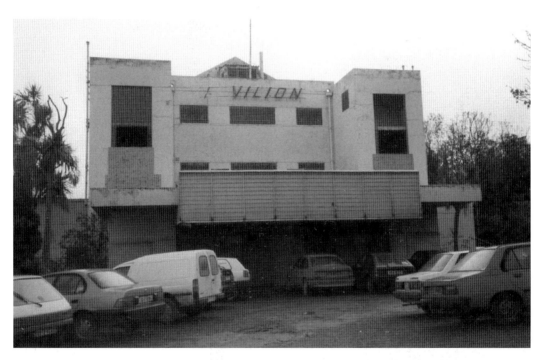

Pavilion Cinema, *c.* 1990. For Health and Safety reasons the Pavilion was closed entirely in 1984 as it did not conform to the newly passed legislation on fire exits, etc. It was then used merely as a car park and fell into further disrepair.

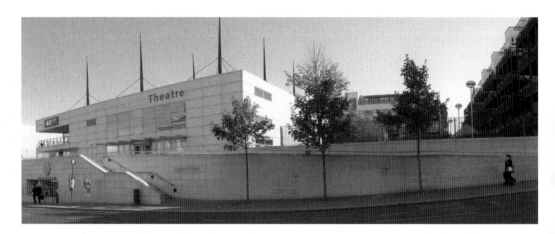

Pavilion Complex, 2004. Eventually the building was demolished and a new complex of retail, residential and leisure facilities was built consisting of shops, restaurants, apartments, and a fitness centre. Maintaining a link with its illustrious past, there is also a theatre on the site, fittingly known as the Pavilion Theatre.

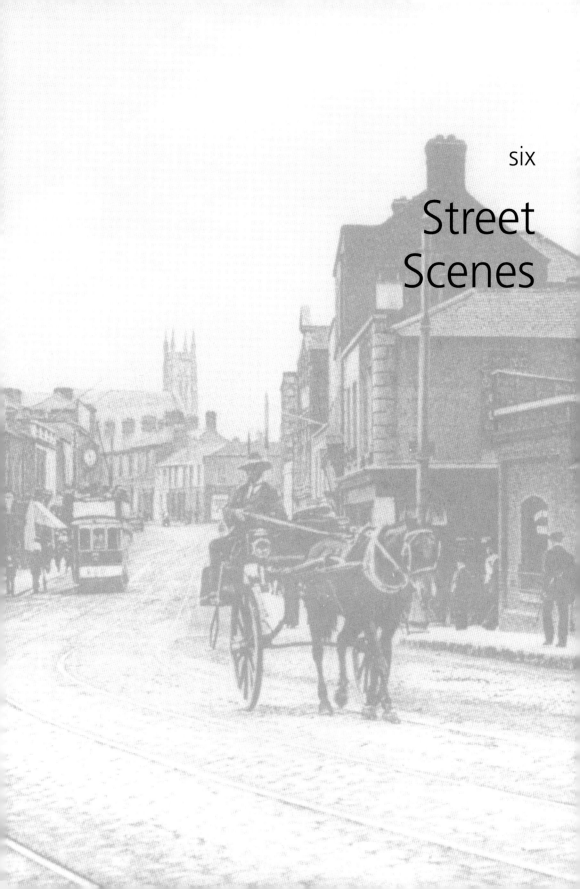

six

Street
Scenes

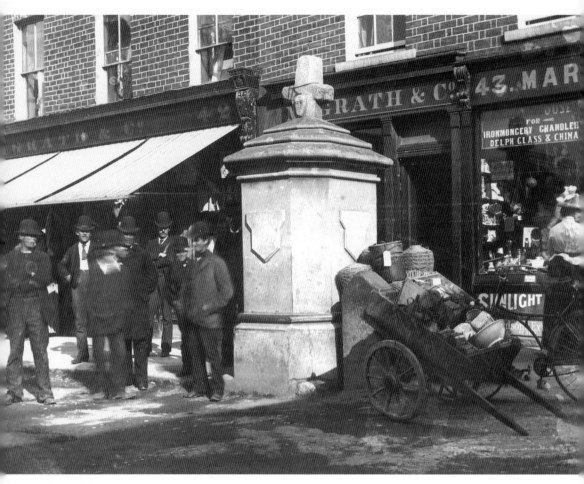

Blackrock Market Cross, *c.* 1905. The cross is of medieval origin, with an image of a human head on one side. Its base and location have been changed a number of times over the years. In 1865 there was an attempt by the Town Commissioners to have it removed from its position. They decided to design another cross to put in its place but there was public controversy and the decision was rescinded. The cross itself was retained though a new base, the one in this photograph, was constructed to support it. The cross with a new base was later moved to its present position on Main Street, Blackrock (see page 126).

Opposite above: Blackrock Market Cross, *c.* 1870. It was traditional for funeral processions to stop and carry the coffin around in a circle in front of the cross. At a later period the shop behind it, though the street numbering differed (44/45 Main Street), was Harts Auctioneer & Valuer, House & Estate Agent and Undertakers. It is now the Central Café.

Opposite below: Carysfort Avenue, Blackrock, *c.* 1925. Blackrock, Kingstown and Dalkey were in the F Division of the Dublin Metropolitan Police districts. According to the Constabulary List and Directory of 1906, candidates for the Metropolitan Police were required to be '… over 21 and under 26 years of age … He must be of strong build and robust constitution, at least 5ft 10in in height without shoes …' Married men were not eligible to join. The DMP wore a very distinctive round helmet. They were phased out in 1925 to be replaced by the Garda Siochana. Carysfort is misspelled in the title of the postcard.

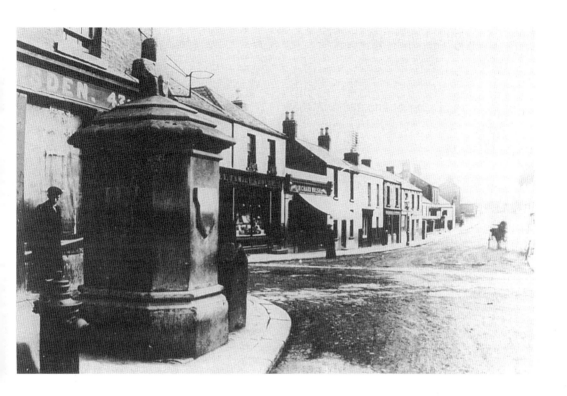

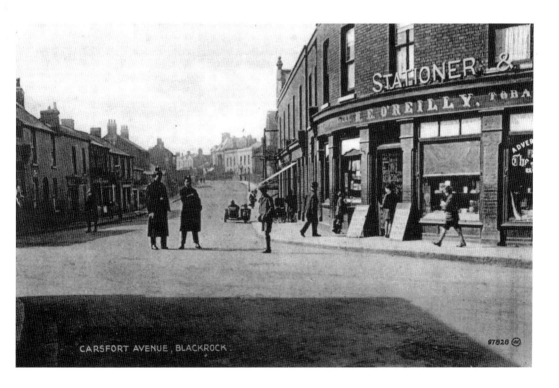

CARSFORT AVENUE, BLACKROCK.

97828

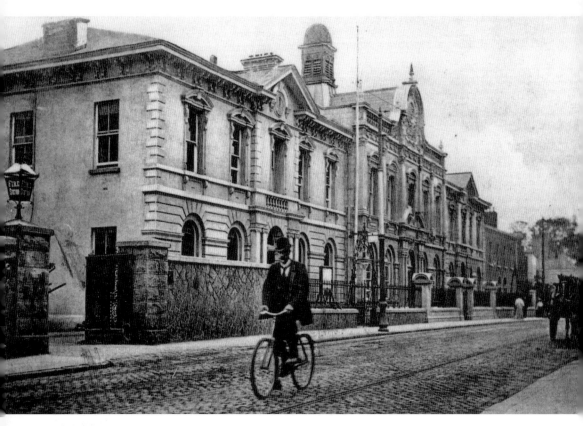

Blackrock Town Hall, *c.* 1900. Blackrock Town Commissioners were established in 1863. The Town Hall itself was completed in 1866; it was '… to consist of Hall, Board Room, Committee Room, Offices and secretary's apartments …' As can be seen it is made up of three parts. Originally it was just the left-hand portion but it was extended in the 1880s. The railings, pillars and flag pole are no longer there. Blackrock merged with Dun Laoghaire, Killiney/Ballybrack and Dalkey to form Dun Laoghaire Borough Corporation in 1930. The bowler-hatted gentleman on the bicycle has to be careful with the cobblestones and the tram-tracks.

Opposite above: Idrone Terrace, *c.* 1900. The railway line runs alongside Idrone Terrace, overlooking Dublin Bay. The houses there were built over a twenty-year period from the 1840-1860s. Both the road and the pavement look in poor condition.

Opposite below: Idrone Terrace, *c.* 1910. This postcard features a number of gentlemen on Idrone Terrace gazing out over Dublin Bay. Contrary to the postcard's title they appear to be looking in any direction but west, not unless they have eyes in the back of their heads. The pavement seems to be badly cracked.

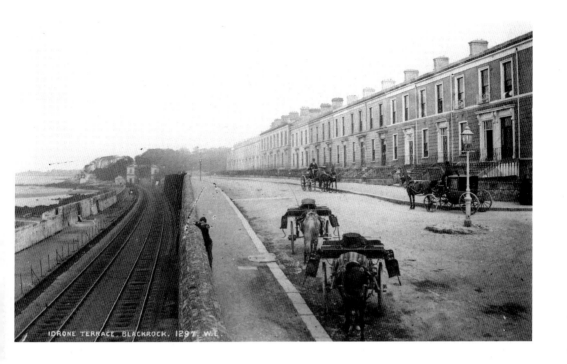

IDRONE TERRACE, BLACKROCK. 1297. W.L.

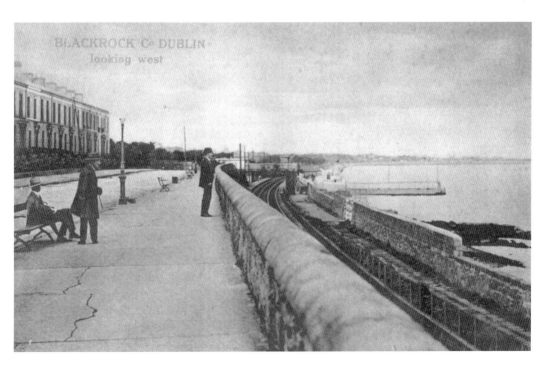

BLACKROCK Co DUBLIN
looking west

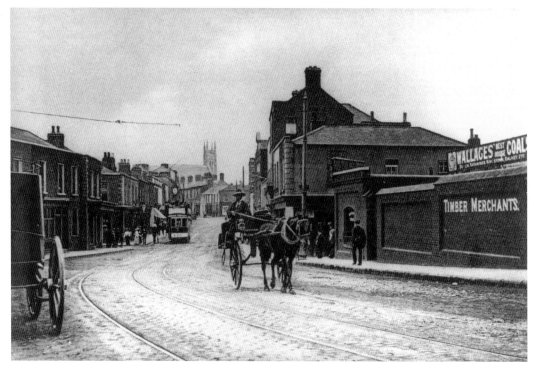

Blackrock Main Street, *c.* 1910. In this view from Rock Hill down Blackrock Main Street, Wallace's Coal Merchants occupied the site which is now in use by Carphone Warehouse. One of the tramline's trolley wires can be seen overhead.

Wallace Brothers were steamship owners as well as one of the areas leading coal merchants; they also had a coal yard in Dun Laoghaire, on Cumberland Street. As might be expected most of the coal was shipped in via Kingstown Harbour.

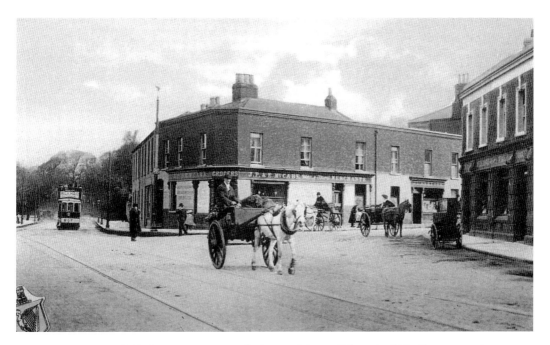

Booterstown, *c.* 1900. Booterstown means the 'town of the road' from the Irish. The man on the cart seems oblivious to the tram coming up behind perhaps because he was too busy looking at the photographer.

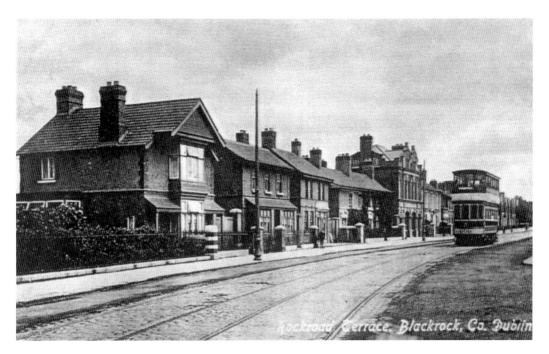

Rock Road, *c.* 1910. Count John McCormack, the renowned tenor lived at Glena on Rock Road in the latter years of his life.

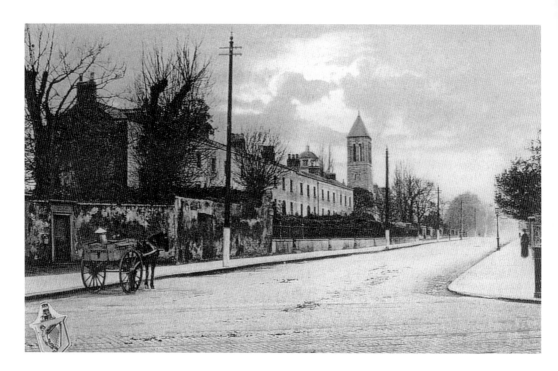

Above and below: The image above of Mount Merrion Avenue from the early part of the twentieth century shows St Andrew's Presbyterian Church which opened in 1899 on the left. From the absence of leaves and the lady on the right being so well wrapped up, it looks like this picture was taken in mid-winter. The symbol on the postcard is a harp and was the emblem of Woolstone Bros., London Postcard Company. The image below of Mount Merrion Avenue from the 1930s shows the opposite vista with the church on the right. The scene looks much less bleak. John Dunlop, inventor of the pneumatic tyre lived on Mount Merrion Avenue for a time.

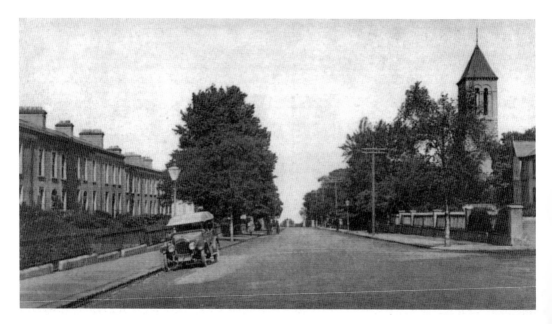

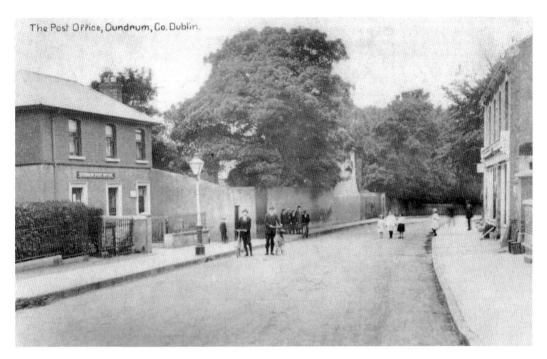

The Post Office, Dundrum, Co. Dublin.

Above: Dundrum post office, *c.* 1900. The Dundrum post arrived twice daily and was sorted in the post office. A postman's route was limited to a one-mile radius of the post office. A Boy Messenger was also available to deliver telegrams.

Below: At the beginning of the twentieth century Rosemount residents like many other residents of Dublin, did not have running water in their houses. Water had to be drawn from kerbside fountains. The child in the photograph looks well wrapped up from the cold. The season is winter from the look of the bare trees. The estate was set in fairly rural surroundings at the time.

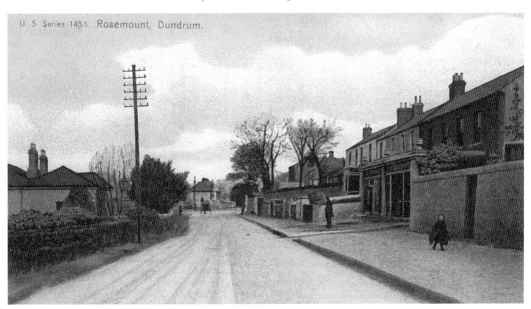

U. S. Series 143/1. Rosemount, Dundrum.

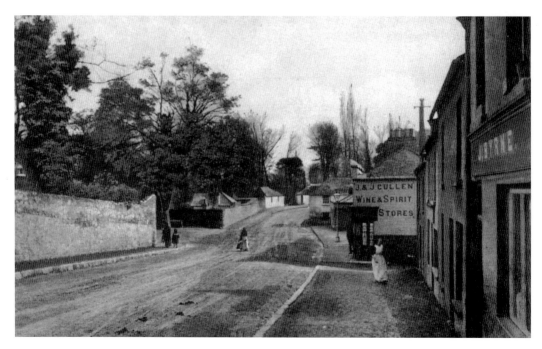

Grove View, Stillorgan, c. 1910. Byrne's Dairy and Cullen's Wine and Spirit store are on the right. Cullen's was a grocery shop as well as a pub in the 1920s and 1930s. As can be seen Stillorgan was very much a rural village at the time.

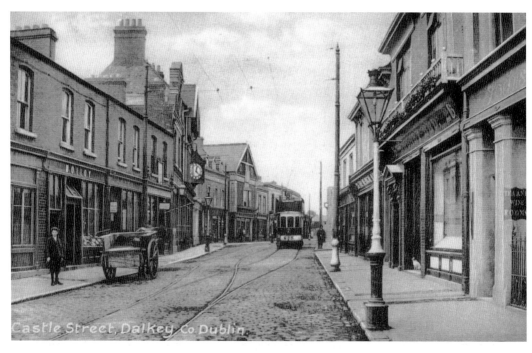

Castle Street, Dalkey, c. 1910. To the left is Molloy's Greengrocers; Findlater's clock can also be seen. On the right, number 26 was Cooney Brothers, victuallers which is now the Laurel Tree restaurant.

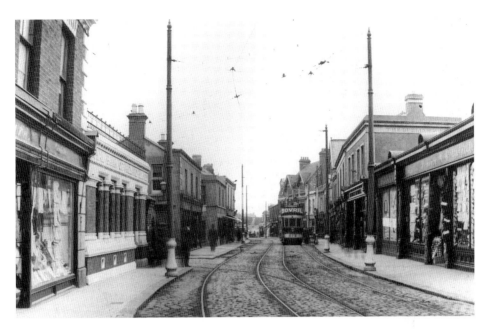

Castle Street, Dalkey, *c.* 1910. To the left, beside the Bank of Ireland, the tram tracks can be seen sweeping across the road into the tramyard. The shop on the right is Doherty and Company, Drapers and Outfitters. The Dublin House can be seen on the side of the two-storey building to the right. Patrick Farrell, a Tea, Wine and Spirit Merchant was the owner. It is now occupied by the Kings Inn pub (Hogans).

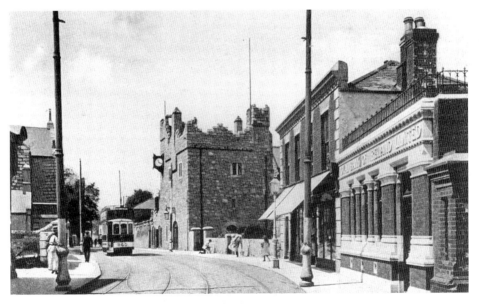

Castle Street, Dalkey, *c.* 1930. The tram is passing Dalkey Castle, one of the several castles in the town which gives the street its name. As the turning circle of the trams was quite wide the trams had to cross over to the wrong side of the road in order to turn into the tramyard. As can be seen the tracks cut across the road.

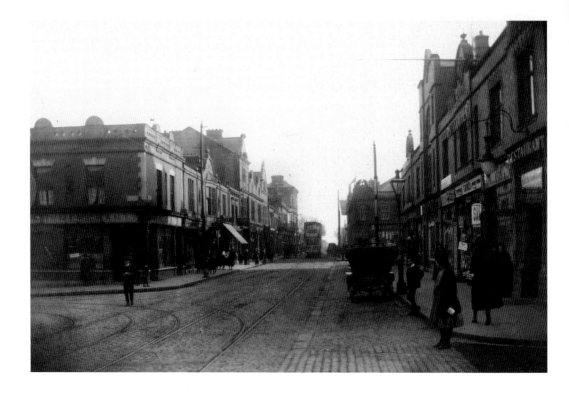

Above: Upper Georges Street, Kingstown, *c.*1900. Cuniam, Tea, Wine and Spirit Merchants occupied the site at the left-hand corner, before the Ulster Bank took it over in 1903. Chas Cook's shop can be seen on the right at number 2 Lower Georges Street where the ESB offices now are. Photography was his principal occupation. His shop was popularly known at the time as a Bazaar. It sold souvenirs and fancy goods and postcards, typical of a seaside resort. The shop survived until 1958. The girl on the right has a cup in her hand and may be collecting for charity.

Left: As the three advertisements to the left show Cooks had a hand in a number of diverse businesses. Cook's telephone number Kingstown 100 shows they were an early adopter of the new communication technology of the time. Though generally known as Chas. Cook, in the middle advertisement he styles himself as C. Neville Cook 'under Royal and Distinguished Patronage'. Cook's also ran a garage, using the same phone number. The garage was on Royal Marine Road. Taxi cabs cost ten pence per mile. Motorcars for hire cost three guineas per day in 1911.

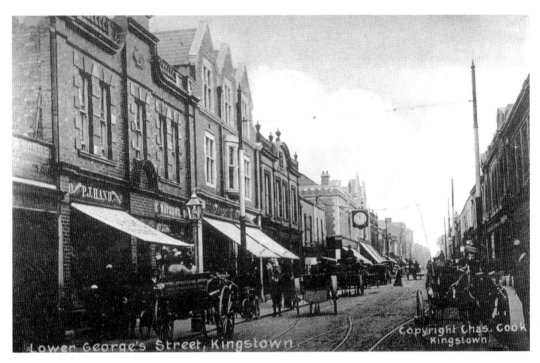

Above and below: Lower Georges Street, *c.* 1905. An example of the photographic works of Chas Cook, it shows a crowded street scene. The clock in the background is at the front of Kingstown branch of Findlaters. Below is a similar view from quarter a century later. HCR (Hayes, Conyngham and Robinson) Chemists can be seen to the right. Findlaters can just be made out to the left, on the site of the present-day Penneys.

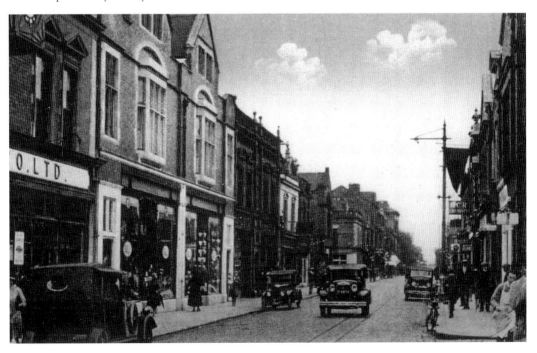

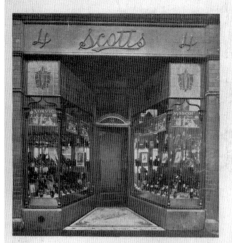

Exterior of Scott's Boot Store, Kingstown.

An Irish Agency.

WE have pleasure in illustrating the interior and exterior of Scott's Boot Store of Kingstown. Mr. Scott has also a branch at Bray, a charming seaside resort some few miles south of Kingstown. Mrs. Scott takes charge of the Bray branch, which is really the parent shop. But Kingstown, we are informed, bids fair to rival the success of Bray. And that is no small success.

The Kingstown shop-front shows what can be done to make a small frontage dignified and effective. The fittings are of oak, the facia of polished granite, and the entrance lobby has a tessellated pavement. The leaded lights above the window add greatly to the artistic effect and help to throw the name into prominence above. The name is the trade-mark, known far and wide in Bray and Kingstown.

Originally the window was flat on to the street, but the new arrangement gives more window space and catches the eye of the passer-by whichever way she is going. It may be added that the position is an exceptionally good one,

facing as it does a street which goes direct to the promenade, the sea and the railway station. Scotts have run Norvic, Diploma and Mascot for a number of years, and the turnover is increasing rapidly—but not half so rapidly as it would if the factory could let Messrs. Scott's have all the goods they ask for in these days.

Do you Know This?

THAT the time allowed for the despatch of Booklets and Circulars (completed or in process of production on or before March 2nd), has been extended until further notice. This means that you are quite in order in sending out the booklets for Norvic, Diploma or Mascot.

If you have used the free supplies we sent you, we can give you further quantities at 2/- per hundred. We have good stocks printed for your use before March 2nd.

WRITE TO THE ADVERTISING DEPARTMENT.

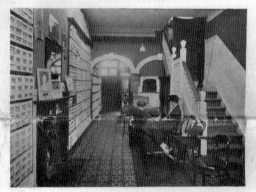

Interior of Scott's Boot Store, Kingstown.

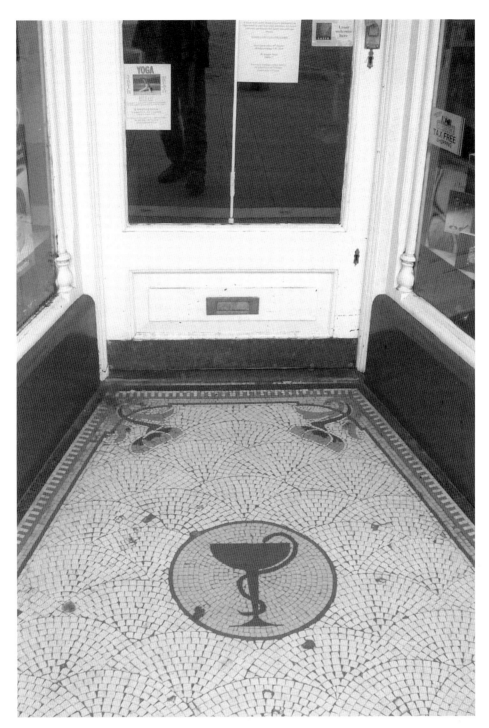

All: Scott's Boot Store was on 4 Upper Georges Street where O'Mahony's Chemist shop is now located. Scott's could be said to be a chain as they also had a premises in Bray which was run by Mrs Scott. The shop in Dun Laoghaire closed in 1971. The mosaic at the front of O'Mahony's is still there from Scott's, though the centre part of it has been modified.

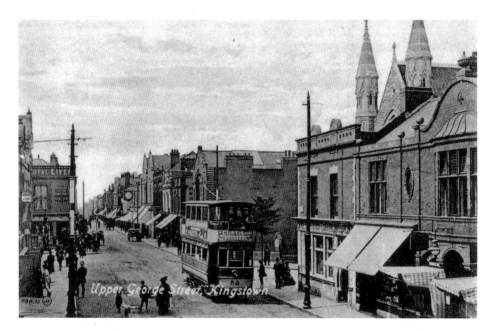

Above: Upper Georges Street, *c.* 1910. The tram on its way to Dalkey is passing the junction with Marine Road. St Michael's Church can be seen in the background. All the buildings to the immediate right of the tram were demolished in 1974 to make way for a shopping centre development. The Ulster Bank moved into the corner site in 1903.

Below: This image of Upper Georges Street from 1973 shows the streetscape immediately prior to the building of the shopping centre. The Ulster Bank retained its location as apparently it held the freehold on the ground.

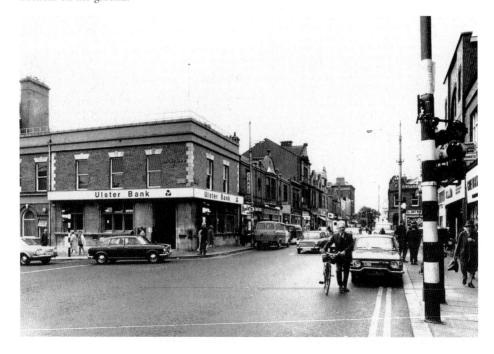

Above and below: Two views of Upper Georges Street, the one above was taken in the late 1980s at the bus stop outside Eason's. Below is present day Upper Georges Street. The Ulster Bank has gone through many changes down through the years but there it is, still on the corner site, after more than a century.

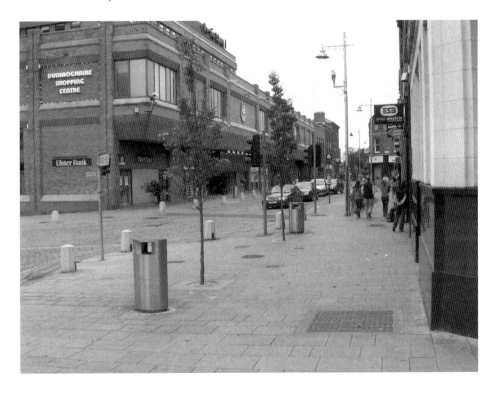

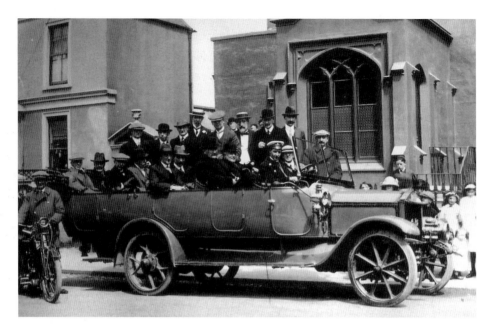

Above: Eblana Avenue, Kingstown, *c.* 1914. This Napier Charabanc is outside the Eblana Lodge. The person on the right at the back of the charabanc bears a strong resemblance to Arthur Griffith. The very distinctive building is still there, home of the Eblana Club.

Below: Royal Marine Road as it was then known at the end of the nineteenth century. Looking down towards the sea observe the cobblestones and the newly erected wires for the electric trams and the row of horse-drawn cabs waiting patiently to the right.

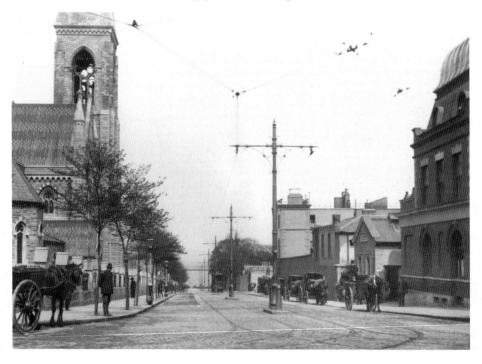

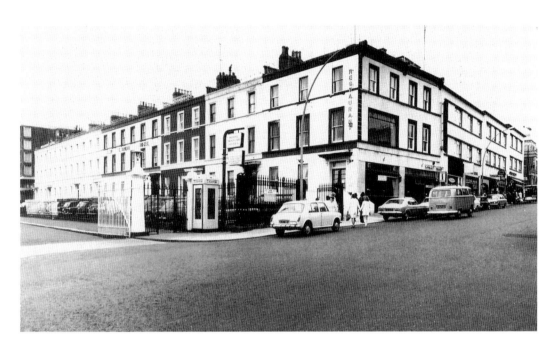

Above and below: Marine Road, Dun Laoghaire, 1973. Taken from Eblana Avenue, it shows the gates of the Royal Marine Hotel and Gresham Terrace to the left. 'Fuller's Restaurant' and the Tourist Office occupied the corner building. All the buildings on Gresham Terrace and those on that portion of Marine Road were demolished as part of the shopping centre redevelopment. The picture below shows Marine Road as it is today. The shopping centre replaced the entire block of buildings.

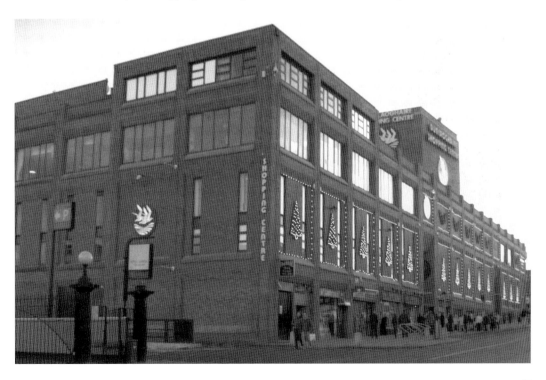

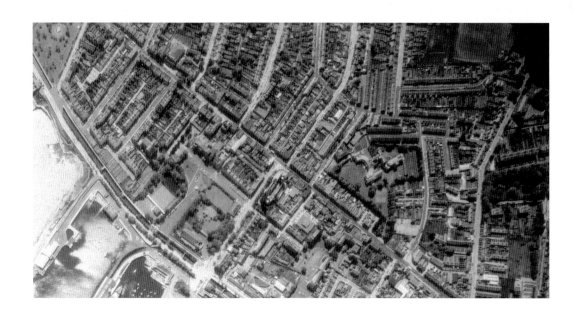

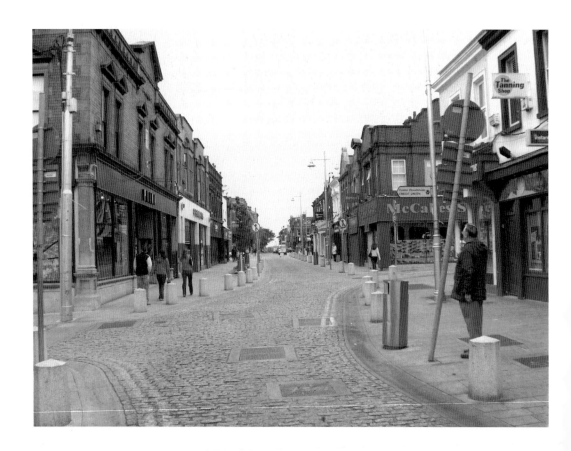

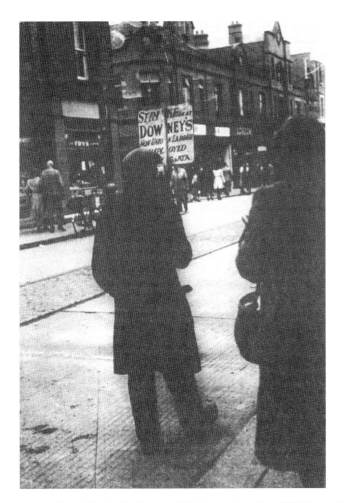

Pub strike that lasted 14 years

TEETOTAL Dun Laoghaire publican Jim Downey said: "Nobody will tell me who to employ in my pub as long as I live".

Teetotal Irish union secretary Walter Beirne said "We'll picket the place for 100 years if necessary".

The scene was set for the longest — 14 years — and strangest strike in Irish history. A strike which was reported in newspapers and magazines from Dun Laoghaire to Durban. It is now recalled by Deansgrange barman, Con Cusack, pictured right at the bar of Eagle House, Glasthule, where he now works.

Con, who was a young apprentice at the time, tells how the trouble began back in 1939. On March 3, Jim the proprietor of the pub in Upper Georges St., Dun Laoghaire, sacked a barman with whom he didn't see eye to eye.

The powerful Irish National Union of Vintners' Assistants ordered the rest of the staff out to picket the premises.

Con married with five children and seven grandchildren — remembers Jim Downey, wasn't standing for this.

'Mr. Downey's answer to the union action was to sack all his staff and replace them with non-union labour.

"When the pub opened on the Monday morning we were there with our placards which read 'Strike on at Downey's'. There were four of us, Paddy Young, the barman, two porters and myself. We each took our turn on the picket line".

"There was never any trouble on the picket," adds Con. "We would shout "strike on here" if too many people passed the picket. On those occasions Jim Downey would call the police".

Summer came and went and the picketing went on.

"I remember well," says Con, "the cold winters. But I never

By Michael Riordan

minded them, you became immune to the cold.'

"The finances of the union were so good that time that all the picketers were getting their full wages".

The pub became the talking point of the town - and it was visited by many foreigners. For many newspapers around the globe, it became a source of comic relief from the terrible news of the war raging in Europe.

Locals in Dun Laoghaire recall when Lord Haw-Haw, in one of his broadcasts, asked: "Is the strike in Downey's still going on?".

A favourite story of the period too was about an Irish seaman captured by a German submarine. The first question the captain asked him when he discovered he was Irish was "Is Downey's strike still on?".

By the time the strike had gone on for five years, the pub became so well known that business was booming. Articles began to appear in such famous publications as Time magazine.

At this stage, after five years on the picket line Con decided to get married: "I found myself another job in the bar trade — but I still did part-time picketing at the pub".

After seven years, Paddy Young, the barman at the centre of the dispute also found employment elsewhere — but the strike went on!.

About the eighth year of the strike a member of the Dail tried and failed to bring Jim Downey and the Union together.

On the anniversary of the start of the strike every year, Jim dressed the pub in bunting and gave free drinks to customers '— and even invited the pickets in!.

In winter, Jim sent out warming drinks for the older pickets. But that did not end the strike.

Mrs. Downey took over the licence and continued his rules about union labour.

"It wasn't until later, when the pub was sold to Mr. Downey's brother-in-law, a Mr. Neville, that the strike ended," said Con.

Strike — on full wages!

HAPPY smiles from Con and a union comrade — never guessing the picket would go on for 14 years.

Above left and right: Downey's Pub was situated at 108 Upper Georges Street and became famous for its long running industrial dispute. The longest strike in Ireland began as a row over union recognition on 5 March 1939. It ended on 5 December 1954. In the meantime it had got itself into the Guinness Book of Records and had become a bizarre sort of tourist attraction. While it had started out quite seriously relations between the publican and the strikers had become quite amicable over the years. Jim Downey would send out hot drinks to the picketers in winter and even allow them to store their placards in the bar. In the 14 years it is reckoned the strikers walked a total of 41,000 miles. The strike was finally resolved with the death of Jim Downey in 1953. The building was later pulled down as part of the Dun Laoghaire Shopping Centre development.

Opposite above: The Irish Air Corps took this aerial view of central Dun Laoghaire in 1968. The Peoples Park can be made out in the top-left hand corner and the long straight road through the centre of the image is Georges Street, Upper and Lower. To the centre-right the Dominican Convent is surrounded by open space, which is now the site of Bloomfield's Shopping Centre. The putting green of the Pavilion Cinema can clearly be seen to the left of centre.

Opposite below: This tranquil view of present day Lower Georges Street shows the newly cobblestoned portion which is pedestrianised with buses the only exception. On the left is Penneys on the site that was occupied for so long by Findlaters.

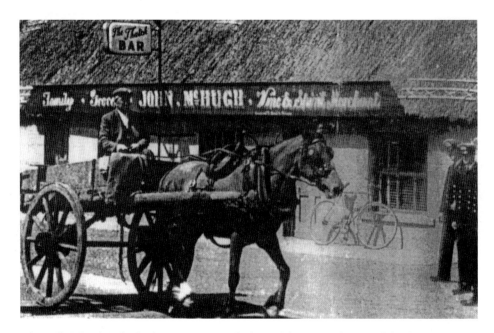

Above: The Thatch Pub, also known as McHughs began life as part of a row of thatched cottages on the Sallynoggin Road. The picture above dates from the late 1950s or early 1960s. The men in uniform on the right appear to be from Irish Lights. The rest of the cottages were demolished over the years but The Thatch survived for over fifty years.

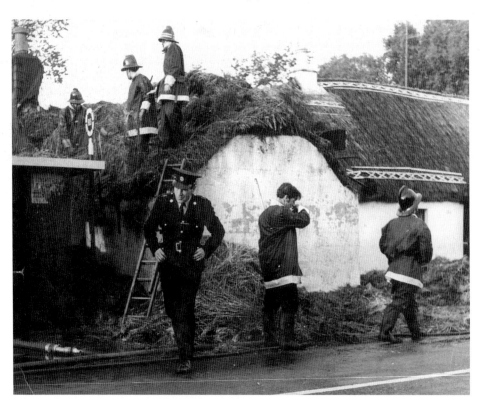

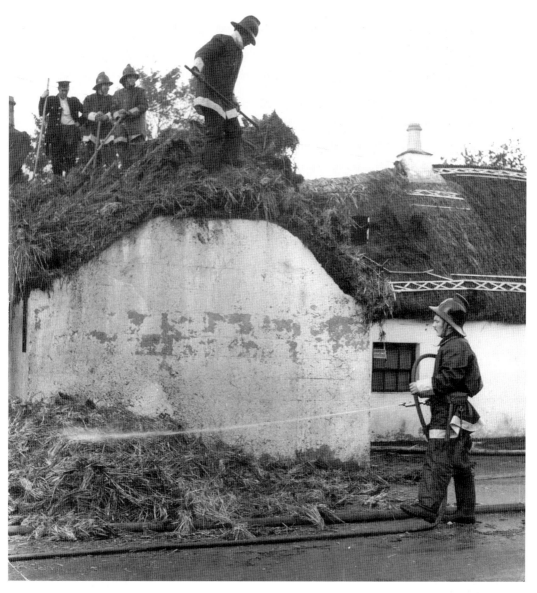

Opposite below and above: However the pub's picturesque thatched roof proved hazardous and it went on fire a number of times over the years. This sequence of pictures depicts the aftermath of a fire in the late 1960s. Local folklore has it that some of the fires may have been deliberate, the work of a disgruntled customer.

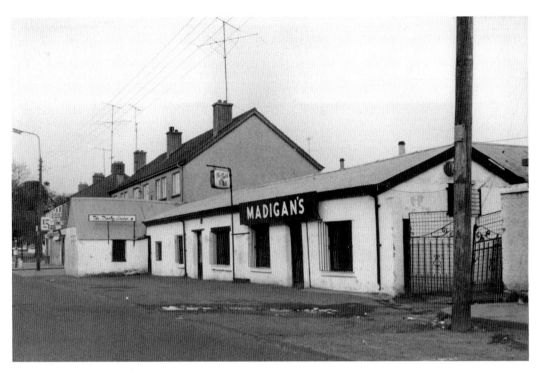

Above and below: As a consequence of the series of fires the thatched roof was replaced with a corrugated metal one, though it was still known as The Thatch. Although the main sign outside said Madigan's, many of the locals still referred to it as McHugh's. The picture above may be the last of the old building as it was taken the day it was demolished in 1972. The picture below shows its replacement. The Thatch was rebuilt on a new site nearby, pictured below, off the main road beside Power City. Now, it too is gone. It closed its doors in 2001.

seven

Trams

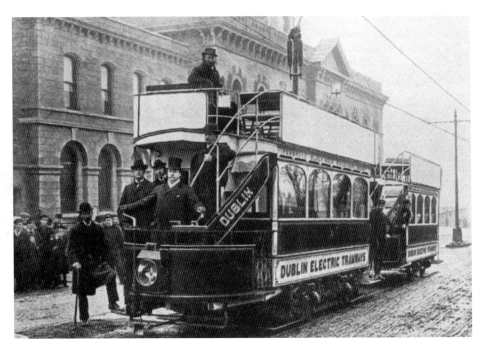

In 1896 outside the Town Hall, Kingstown, this photograph was staged to mark the launch of the Dublin Electric Tramways service to Dalkey. A well-known Kingstown character, newspaper seller, Davy Stephens is upstairs. The managing director of Dublin United Tramway Company, Clifton Robinson is at the controls. A notice from the Freeman's Journal 16 May 1896, 'A tram every 10 minutes between Haddington Road and Dalkey is ample provision for the requirements of the public'.

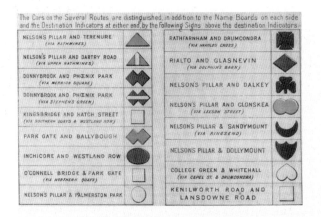
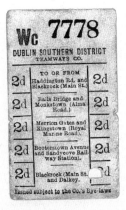

Tram symbols, c. 1903. Originally the trams used colour coding rather than numbers. The 1881 census had shown that nearly one quarter of Dubliners were illiterate. Symbols first appeared in 1903. The symbol for the Dalkey route was a shamrock. In 1918 the numbers were introduced. From Nelson's Pillar, Route Six ran to Blackrock, Route Seven to Kingstown and Route Eight to Dalkey. The ticket stub shows that a journey from Balls Bridge to Monkstow (Alma Rd) would cost 2d.

Marine Road, Kingstown, *c.* 1900. A tram passes by some horse-drawn cabs. The square tower of the old St Michael's Church can be seen to the left. In the distance, at the bottom of Marine Road, a number of cranes are in action; perhaps the early stages of the construction of the Pavilion Gardens are under way. Understandable there was some resentment from the cabmen towards their new competitor, the trams.

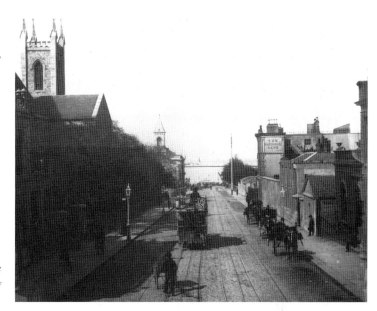

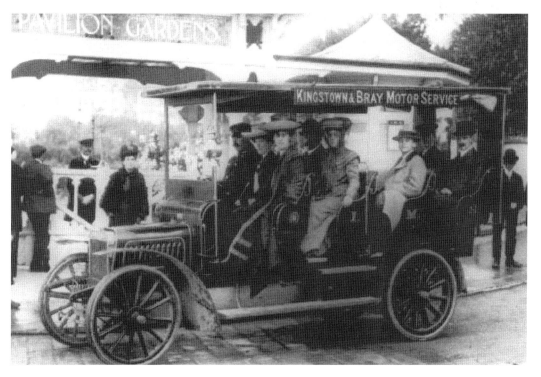

Kingstown & Bray Charabanc, *c.* 1905. Charabancs were the early forerunners of buses. The I.M.S stood for the Irish Motor Service Company. It ran a route from Kingstown to Bray from 1905. This photograph was taken just outside the entrance to the Pavilion Gardens. The charabanc is open to the elements so the passengers are well wrapped up. Up until 1896 the Locomotives on Highways Act had decreed that for safety purposes a man with a red flag walk in front of every mechanically propelled vehicle.

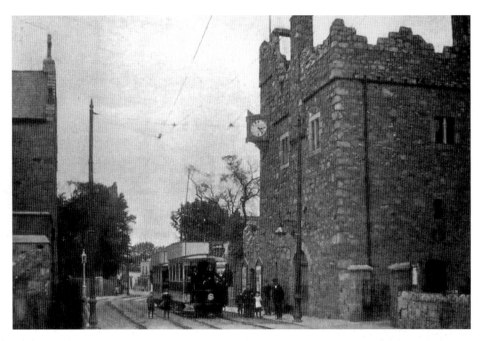

Above and below: This image from 1896 shows the new electric trams outside Dalkey Castle, possibly on a trial run. The castle served as Town Hall for Dalkey and also housed the children's library for a time. It now houses Dalkey Heritage Centre. The tram below is taking the sharp left turn into Castle Street. Across the road can be seen Ivory's which was a Grocer's, Wine & Spirits Provision Merchant. The post office and Dalkey Hair Design now occupy the sites to the left. Note that the upper-deck of the tram has panelling. These so-called 'decency boards' were fitted so that no passer-by might accidentally get a glimpse of delicate female ankle. As a bonus it turned out that these boards provided ample space for advertising.

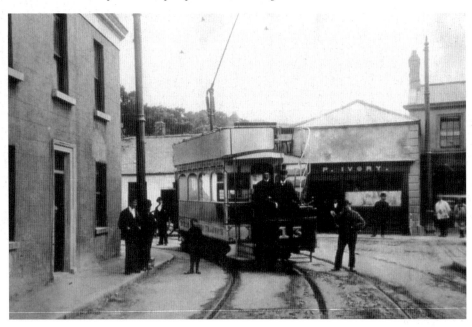

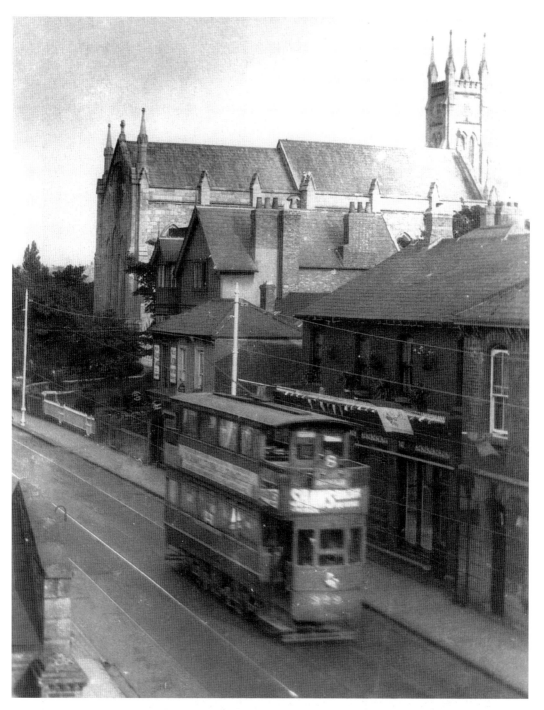

Blackrock Tram, *c.* 1930. The slightly blurred image might give the impression that the tram is moving faster than it is. Early speeds were a maximum of twelve miles an hour. This balcony car on the number eight route was built in Spa Road, Inchicore in 1908 and was not replaced until 1934. It is travelling towards Blackrock on Newtown Avenue in the same direction as the one-way traffic system in operation at the moment.

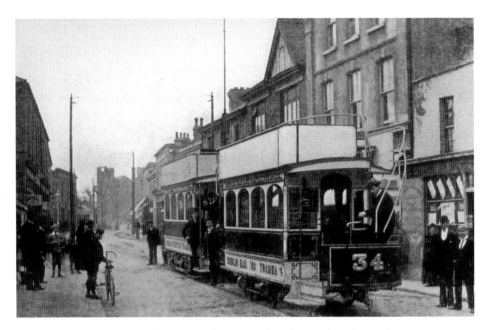

Above: Castle Street, Dalkey. This picture of a tram with trailer may have been taken during testing of the line and training of the staff before the line was opened in 1896. The first fatality for the new form of transport was of a young woman named Maggie O'Donnell who on 18 July 1897 was cycling in Dalkey when she got trapped between the tram and a horse-drawn car. She fell from her bike and was run over by the tram. The trailers were phased out after another fatality in 1898 in Merrion Square at the Holles Street stop when a passenger fell between the two parts of the tram and was crushed.

Below: In 1937 Dublin United Tramways Company decided to embark on a policy of replacing all their trams with buses. The Dalkey route lasted until 1949. The 284, pictured above in Dalkey depot was in use until the line's closure.

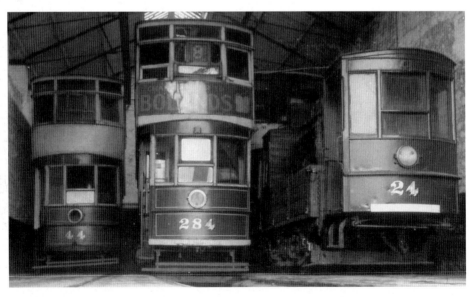

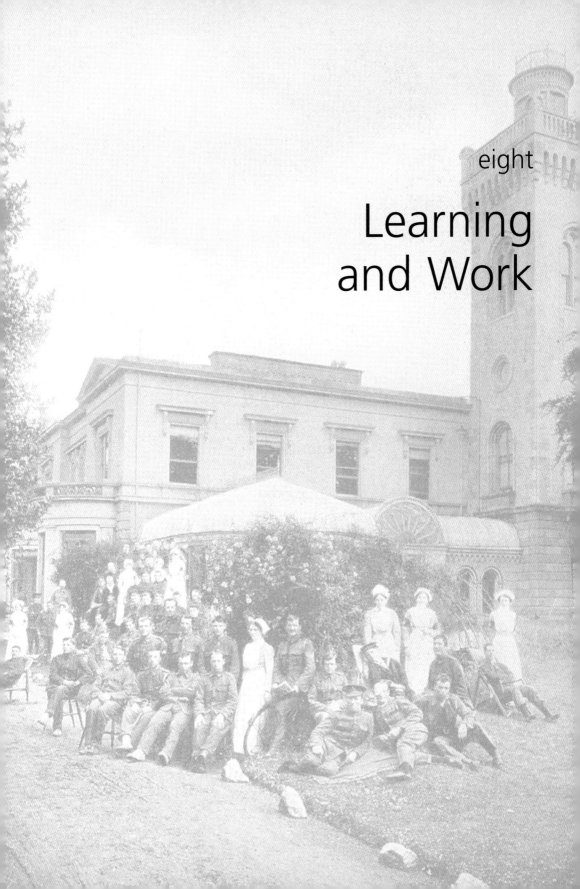

eight

Learning
and Work

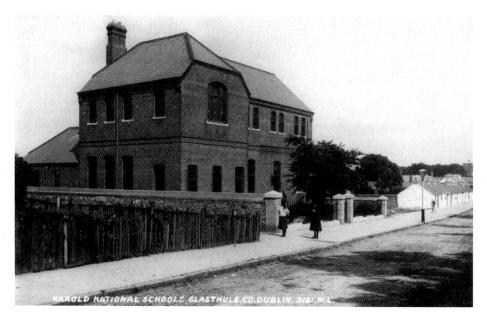

Above: Harold Boy's School, *c.* 1900 was built in two instalments over a ten-year period from 1900 to 1910. This may account for its asymmetrical appearance in this image. Only half of the present-day building had been completed. The very small looking cottages of Perrin's Row in the background are no longer there. The road in front of the school is in very poor condition.

Below: Blackrock College, 1904. Founded by the Holy Ghost Fathers in 1860, Blackrock College is one of the most famous schools in Ireland. The school has been associated with past pupils as varied as Eamon de Valera and Bob Geldof. The postcard shows an art class been taken by Fr. J.M. Ebenrecht. In addition to being an art teacher, he drew up the plans for the College Chapel, built in 1867. He was also architect of the enlargement and restructuring of Williamstown Castle in 1905.

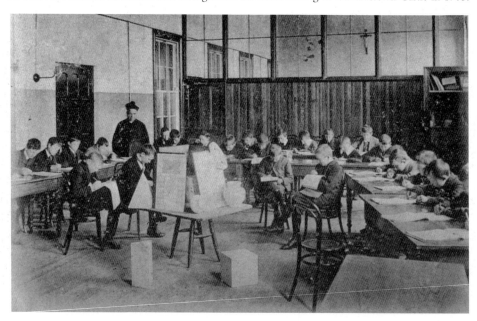

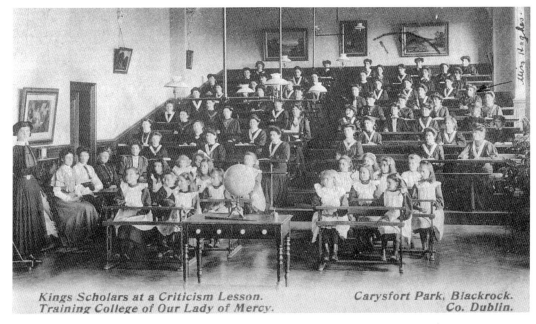

Kings Scholars at a Criticism Lesson.
Training College of Our Lady of Mercy.

Carysfort Park, Blackrock.
Co. Dublin.

Above and below: Carysfort College, Blackrock, *c.* 1903. The Sisters of Mercy established a Primary School teacher-training college for women in Blackrock. On this postcard someone has put a name 'Miss Hughes' beside the student at the window in the top right hand corner. Student teachers at these training colleges were known as Queen's Scholars or King's Scholars. Future president Eamon De Valera was a teacher of mathematics at Carysfort Training College from 1906 to 1916. According to his employers, '… his worth was manifest and he was thoroughly appreciated by all of us. His devotedness to duty and his manly piety were an example to us all'.

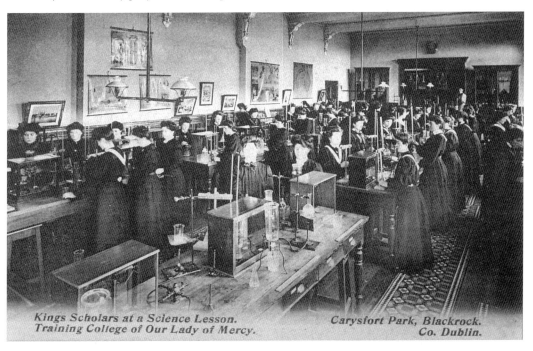

Kings Scholars at a Science Lesson.
Training College of Our Lady of Mercy.

Carysfort Park, Blackrock.
Co. Dublin.

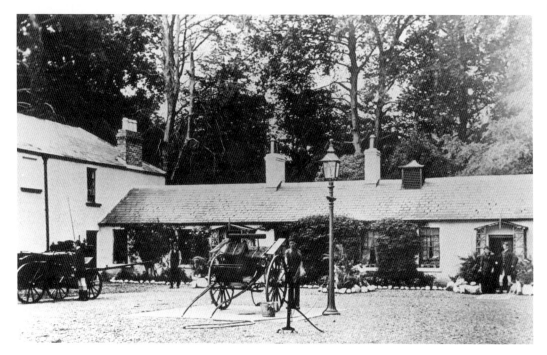

Above: Old Connaught House, Ferndale Road, Shankill, staff cottages and yard, *c.* 1900. There were a number of Big Houses in the Dun Laoghaire area. They employed a great many local people. Largely rebuilt in the early nineteenth century, Old Connaught House was the property of the Plunkett family. Sir Walter Scott is reputed to have stayed there in 1825. A listed house on 8 acres, it was recently sold for €4.3 million for conversion to luxury apartments. As can be seen the carriage in the centre is being washed down while a number of people in horse riding gear look on.

Below: Loughlinstown House, *c.* 1930. The Domvile family who had large estates in the Shankill/Ballybrack/Loughlinstown area owned Loughlinstown House though they did not always reside there. It now houses the European Foundation.

Above, Blackrock Library, *c.* 1910. The Town Hall was built in 1866 and extended in the 1880s. Part of the building houses the Carnegie Library, which was opened to the public in 1905. It celebrates its centenary in 2005. Below is an image of Dun Laoghaire Library taken in 1934. The library building itself is little changed though all the structures around it certainly have. As the inscription over the door states, Dun Laoghaire is also a Carnegie Library, opened in 1912. Andrew Carnegie, born in Scotland, became a multi-millionaire in the oil and steel business in the United States. He funded the construction of a number of libraries in Britain and Ireland. Dalkey, Cabinteely, Shankill, Glencullen, Sandyford and Dundrum branch libraries were also Carnegie-funded. Most of them are still in library use. Note the cobblestones and the tramlines and the bicycle parked alongside the steps.

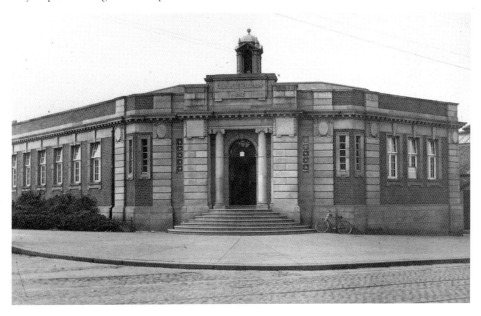

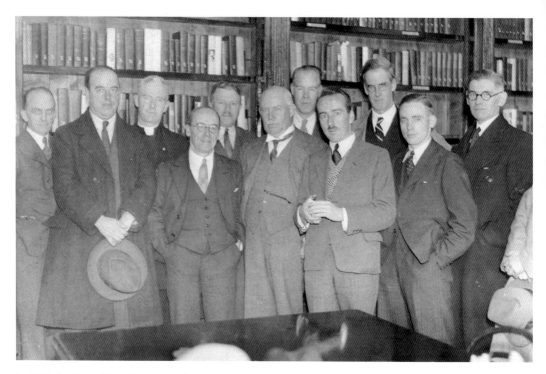

In 1930 the Townships of Dun Laoghaire Dalkey, Blackrock and Killiney/Ballybrack merged to form the new Dun Laoghaire Borough. In this photograph taken in Dun Laoghaire library in 1934 James Gaffney is fourth from the right. He became Borough Librarian of the newly created Library Service in 1933. He retired in 1961.

Superintendent C. Dunleavy,
"F" Division,
Garda Siothchana,
DUN LAOGHAIRE.

FIFTEENTH
August
19 35

A chara,

Further to my telephone report concerning the breaking of a pane of glass in this library by a missile thrown from the outside, and also to my letter of 30th May last reporting a similar occurrence here I have again to appeal to you for assistance in protecting the ratepayers' property from damage of this nature.

I should be glad if you would kindly let me have a written acknowledgement of the receipt of this report.

Mise, le meas,

Borough Librarian.

GARDA SIOCHANA (METROPOLITAN DIVISION)

....District,
Superintendent's Office,
Dun Laoghaire.

17th. August, 1935.

J.H. Gaffney Esq.,
Borough Librarian,
Central Public Library,
Dun Laoghaire.

A Chara.

Damage to Window of Library.

I beg to acknowledge receipt of your communication of 15th. instant relative to above and in reply to state that on receipt of your telephone report I detailed a plain clothes Gards to make every endeavour to trace the culprit responsible for the throwing of the missile mentioned. In addition to above I have now detailed a uniformed Garda to pay particular attention to youths congregating in the vicinity of Central Library and every assistance will be given in the protection of public property.

Mise, le meas,

(CHAS.DUNLEVY) Ceannphort,

As this correspondence shows life in the library service was not always as peaceful as some people might imagine.

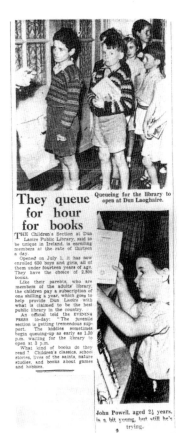

They queue for hour for books

Queueing for the library to open at Dun Laoghaire.

THE Children's Section at Dun Laoire Public Library, said to be unique in Ireland, is enrolling members at the rate of thirteen a day.

Opened on July 1, it has now enrolled 650 boys and girls, all of them under fourteen years of age. They have the choice of 2,800 books.

Like their parents, who are members of the adults' library, the children pay a subscription of one shilling a year, which goes to help provide Dun Laoire with what is claimed to be the best public library in the country.

An official told the EVENING PRESS to-day: "The juvenile section is getting tremendous support. The kiddies sometimes begin queuing-up as early as 1.30 p.m. waiting for the library to open at 3 p.m.

What kind of books do they read? Children's classics, school stories, lives of the saints, nature studies, and books about games and hobbies.

John Powell, aged 2½ years, is a bit young, but still he's trying.

Right: As the population of the Borough grew so did the demand for a Library Service particularly for children as this clipping from the Evening Press, September 1954 shows.

Below: Dundrum Library, *c.* 1920. Dundrum Library was opened in 1914. It was also a Carnegie Library. Like many village libraries it was also a focal point for social and community activities. The upper room in the library had a stage. Originally it was intended as a lecture room but it was also used as a public hall for concerts, dances, ceílís, plays and even jumble sales.

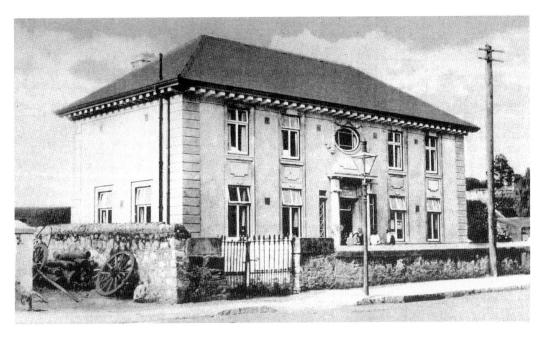

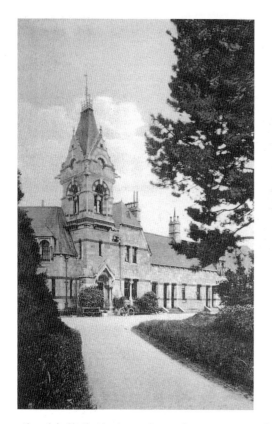 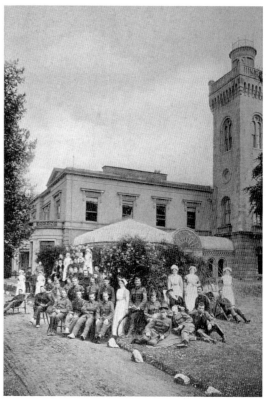

Above left: Sheils Almshouse, Leopardstown, *c.* 1910. Charles Sheils was a prosperous merchant, a native of Killough, County Down who was widowed early in life. The Charles Sheils' Almshouses Charity Act of 1864 set up the charity '… to house people of small income who have seen better days … gentle ladies of slender means'.

Above right: Monkstown Auxiliary Hospital, *c.* 1918. During the First World War a number of houses in the South Dublin area were loaned to the Ministry of Pensions for use as auxiliary military hospitals. Leopardstown House, Stillorgan Convalescent Home and Monkstown House were among the establishments used for this purpose. Most of them reverted to civilian use after the war.

Opposite above: Meath Industrial School, Carysfort Avenue, *c.* 1918. The Meath Industrial School for Protestant Boys was opened in 1875 as a reformatory school for homeless boys some of whom were shipped off to Canada. It was set up under the patronage of the Earl of Meath. James Stephens, the famous Irish novelist and poet was sent to the school after being abandoned by his mother. It was used as a hospital during the First World War and subsequently was known as the Military Orthopaedic Hospital. The building is now part of a business park. Ministry is misspelled in the title.

Opposite below: 'Adequately heated in cold weather' and 'terms moderate', how could one resist? This advertisement from the early 1950s shows the central building of the Dominican Convent, formerly Echo Lodge. It was demolished to make way for Bloomfield's shopping centre.

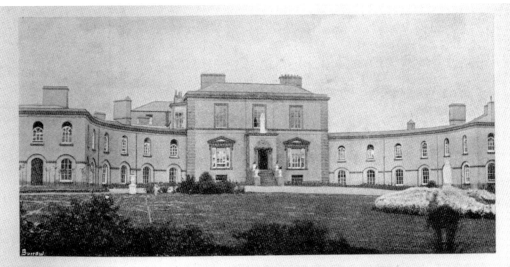

St. Mary's Dominican Convent
DUN LAOGHAIRE
Founded 1847

High School for Resident and Extern Pupils

Large, well-ventilated Classrooms adequately heated in cold weather.
Spacious grounds for organised games.

Terms Moderate. *Apply to Mother Prioress*

See also Space No. 21

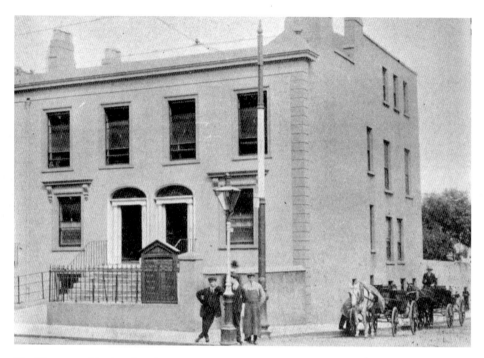

The Kingstown Municipal Technical School operated from this building on Upper Georges Street at the junction with Mellifont Avenue at the beginning of the twentieth century. It moved to Eblana Avenue in 1907 to the site of what is now the Senior College, Dun Laoghaire. Offices now occupy the buildings at 78/79 Upper Georges Street.

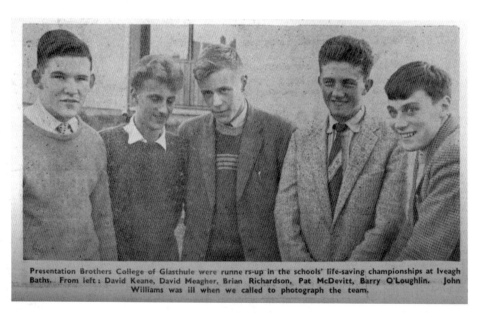

Presentation Brothers College of Glasthule were runne rs-up in the schools' life-saving championships at Iveagh Baths. From left: David Keane, David Meagher, Brian Richardson, Pat McDevitt, Barry O'Loughlin. John Williams was ill when we called to photograph the team.

This press clipping from the *Dublin Post* dates from 1960. After operating for more than a century the Presentation College Glasthule is due to close in June 2007, due to a declining number of students.

nine

Findlater's

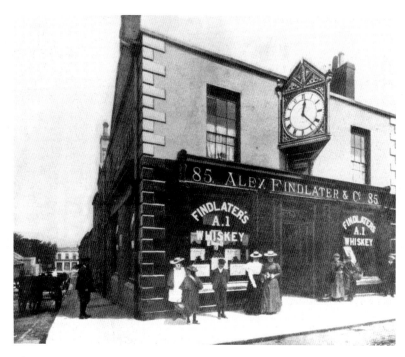

Above and below: Lower Georges Street, Kingstown, *c.* 1900. For a time Findlaters were Dublin's most well known and prestigious wine and food business with branches throughout the city. The Kingstown shop was one of the earliest opened in 1830, four years before the railway was built. Note the distinctive clock, a feature of many of the Findlater shops. The clocks were part of Findlaters appeal. In the days before cheap and accurate wristwatches became available they provided a very useful public service. As a newspaper report from the *Evening Herald of 1906* states'… a fine public clock, a delightfully clean, smart frontage and an air of prosperity are the characteristics of all the Findlater branches'.

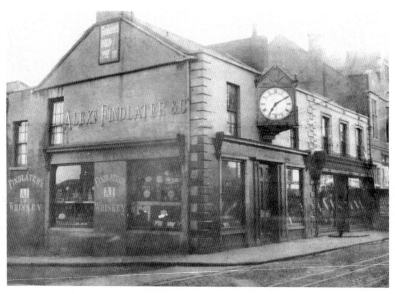

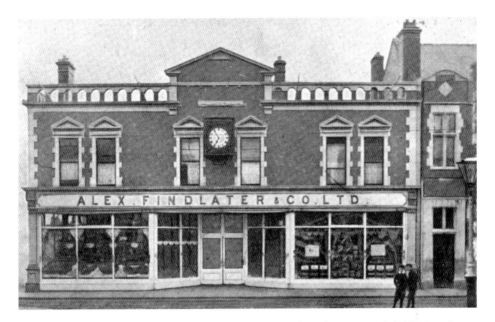

Above: At the end of the nineteenth century the Kingstown branch was expanded. *The Saturday Herald* reported in 1903 that the shoop was enlarged '… to enable the management to cope with the large and growing business with which they are favoured … Kingstown can be said to be the most important of all the branches, as it is favoured with the patronage of a big percentage of the leading residents of South Dublin'. Note that the old two-sided clock had been replaced by a three-sided version.

Below: Main Street, Blackrock, *c.* 1900. Taken from the location of the Market Cross this view down Main Street shows the distinctive Findlater's clock. All the local youths seem to be congregating to watch the photographer at work.

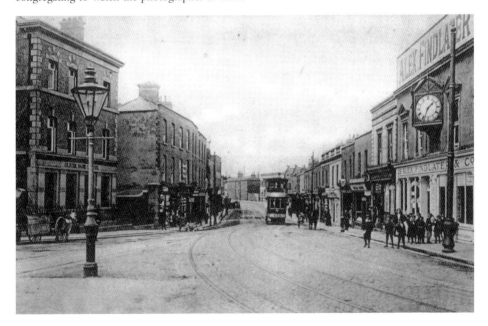

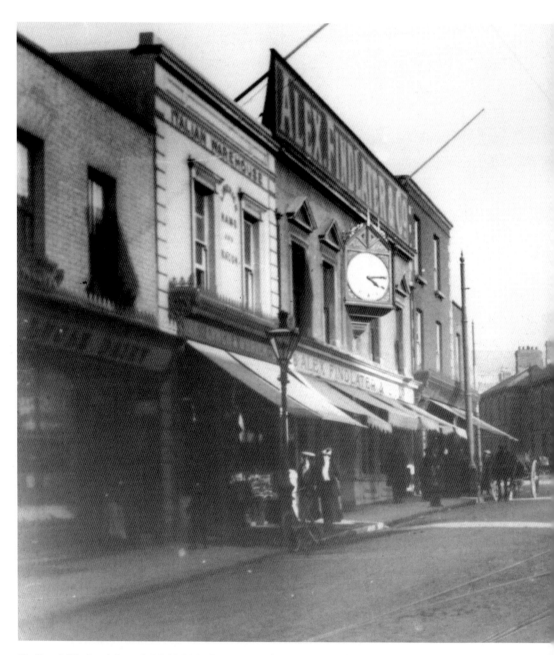

Findlater's Blackrock branch 28-30 Main Street opened in 1879. Note how the tramlines curve away from the shop so as to leave room for deliveries directly to the front door. The Bank of Ireland now occupies the site.

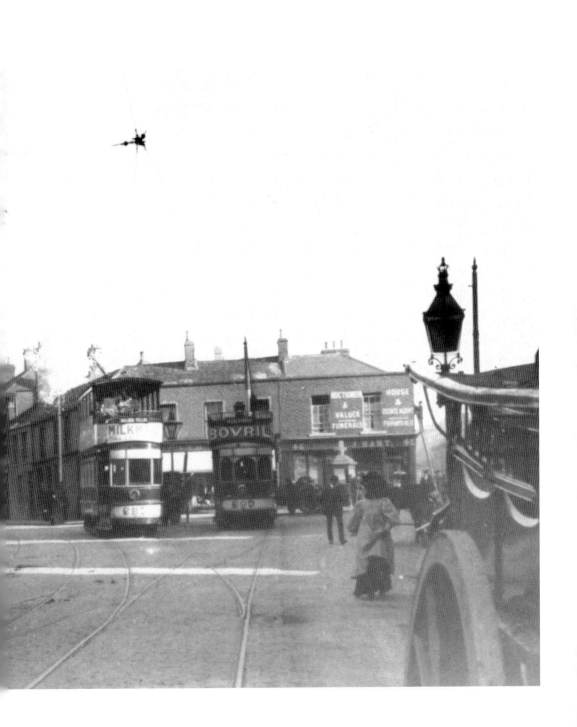

Above: Findlater Street in Glasthule, completed in 1899 is named after Adam S. Findlater who served as a councillor on Kingstown Town Commission from the 1880s to 1901 including several terms as chairman. Adam Seaton Findlater Senior had been the main partner in the family firm with Alexander Findlater, the founder. The 39 houses were built by the Dublin Artisans Dwellings Company, as were the nearby Coldwell Street and Eden Terrace.

Left: Coldwell Street, Glasthule. Note the foot scraper beside the door of the house. Each of the cottages had one of these to remove the mud of the artisan's boots before entering their homes after a hard day's work.

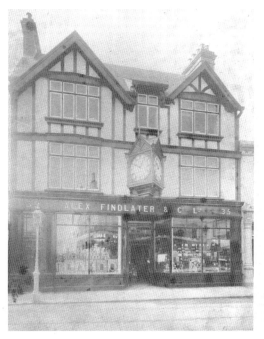

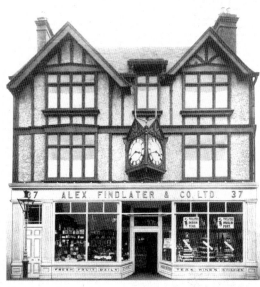

Above: Castle Street, Dalkey, *c.* 1900. The firm expanded rapidly towards the end of the nineteenth century. The Dalkey shop opened in 1898 and survived until 1969. There seems to have been some early confusion as to the street numbering in Dalkey. At different times the same shop was number 35 and number 37. Number 37 is the correct numbering. The site is now occupied by the Eurospar store. The distinctive clock is still there though it is purely for ornament, it no longer tells the correct time. Note the ad in the window for Findlater's Invalid Port!

Right: Findlaters branch in Kingstown was a supplier to the mailboats until the 1960s.

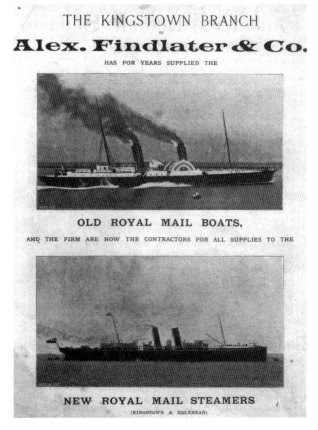

THE KINGSTOWN BRANCH
of
Alex. Findlater & Co.
HAS FOR YEARS SUPPLIED THE

OLD ROYAL MAIL BOATS,

AND THE FIRM ARE NOW THE CONTRACTORS FOR ALL SUPPLIES TO THE

NEW ROYAL MAIL STEAMERS
(KINGSTOWN & HOLYHEAD)

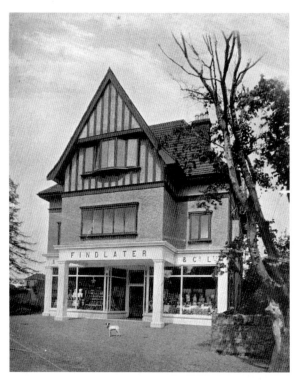

Left: Findlater's Foxrock Village, *c.* 1940. In Foxrock Village, this branch opened in 1904, it now houses The Gables Restaurant. To the left of the building the railway bridge, part of the old Harcourt Street line can just be made out. By 1934 this branch was taking so many orders by phone that it had an extra line installed. The shop's telephone number was changed from Foxrock 9 to Foxrock 208 and Foxrock 209.

Below: Findlaters Kingstown. Changing social conditions and competition from new supermarkets undermined the business and the shops were sold in 1969. Findlaters was relaunched as a wine merchant company. Penney's now occupy the site on Lower Georges Street, Dun Laoghaire.

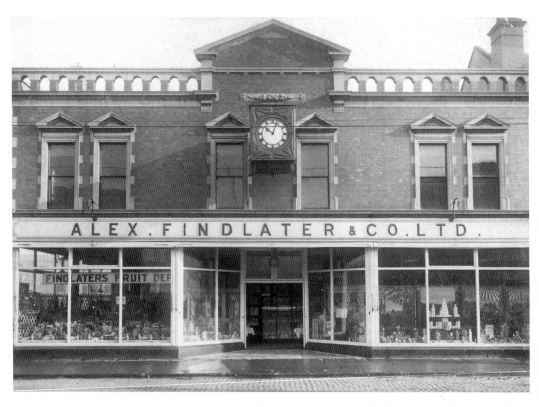

Worship

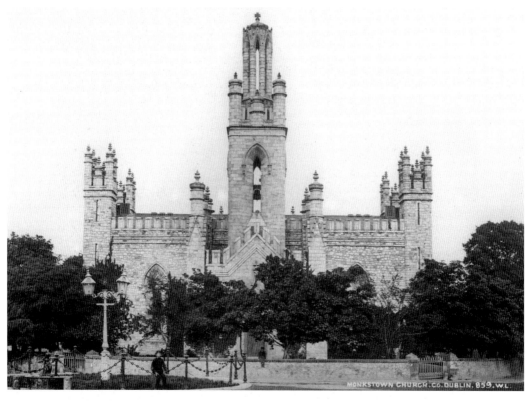

Monkstown Church, *c.* 1900. Monkstown Church of Ireland parish church was rebuilt in 1831. Designed by John Semple, its spires have often been compared to chess pieces. The poet John Betjeman was a great admirer; he called it ' ... a cheerful Irish Castle with a seaside rather than a fortress flavour ... make Monkstown Church one of my favourites for its originality of detail and proportion'. In later life John Betjeman became a patron of the Friends of Monkstown Church inaugurated in 1974. The purpose of the Friends was to raise funds for the upkeep and repair of the Church.

Monkstown Church, *c.* 1900. In 1896 the select vestry of the church resolved to write to the manager of the Dublin United Tramway Company complaining about the new trams and the 'ringing of bells during service when passing the church'.

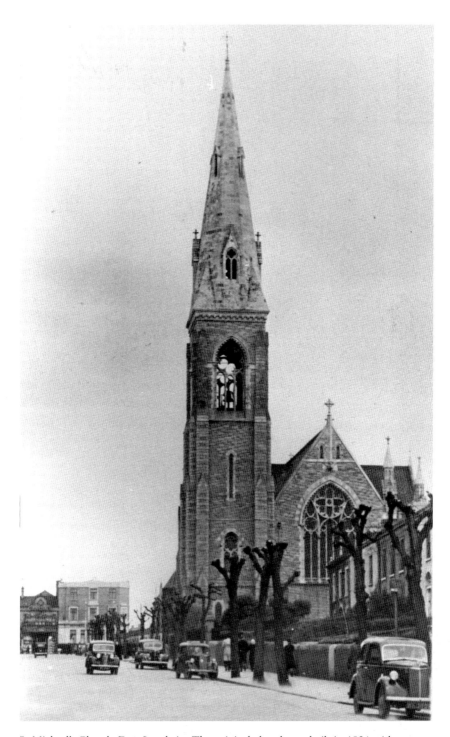

St Michael's Church, Dun Laoghaire. The original church was built in 1824 with a rectangular tower. It was enlarged in 1869 and again in 1892. John L. Robinson, who also designed the Town Hall, St Michael's Hospital and the People's Park, designed the new spire. He also served as chairman of Kingstown Town Council.

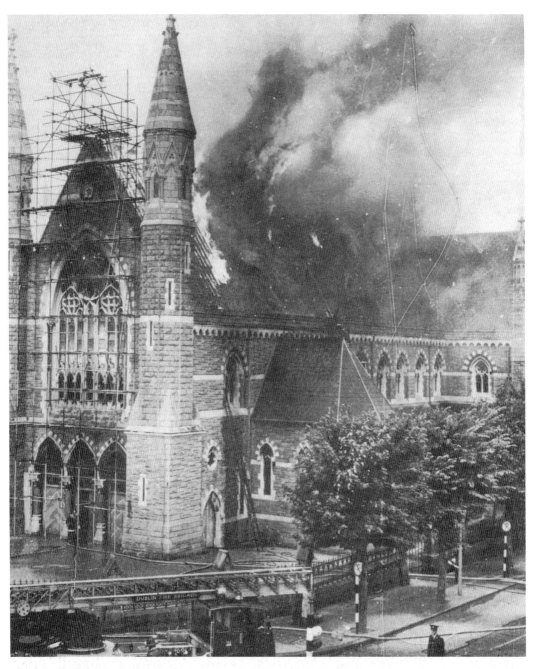

St Michael's Church burned down in 1966. The spire known as as the Bell Tower survived. It now houses the youth information centre.

Right: There was a great deal of public concern at the speed
with which the fire destroyed the church as this excerpt
from the Borough Council Minutes of 6 September 1965
demonstrates. Though the cause of the fire could not be
ascertained it was generally believed to be an electrical fault in
the organ loft.

Below: Mariner's Church, *c.* 1890. Opened in 1837 'for the
benefit of sailors in men-of-war, merchant ships, fishing boats
and yachts'. Originally much plainer, it was remodelled in
1871 and its tall, narrow Gothic spire gave it a more elegant
appearance. It is apt that it now houses the National Maritime
Museum. The Royal Marine Hotel can be seen to the right and
what seems to be the Pavilion Gardens' tennis court can just be
made out in the foreground.

Saint Brigid's, Stillorgan, *c.* 1900. The church was built in 1712 on the site of a previous church and was added to around 1812. Beside the church were 'the poor schools', also called St Brigid's, a boy's and girl's school. The girls in the photograph were more than likely pupils.

St Nahis Graveyard, Dundrum. St Nahi's is an eighteenth-century church built on the site of a seventh-century monastery. The church contains several stained-glass windows by Evie Hone and some tapestries by the Misses Yeats, Susan and Elizabeth known as Lily and Lolly, sisters of W.B. and Jack B. Yeats. They are buried in the graveyard. Though St Nahis is Church of Ireland, Protestant and Catholic shared the cemetery. There is also a burial plot for inmates of what was called the Central Lunatic Asylum for the Reception of Insane Persons when it opened in 1850. It is now known as the Central Mental Hospital.

eleven

Ancient
Spaces

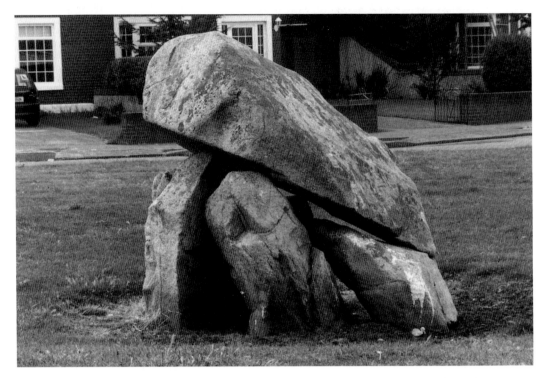

Ballybrack Dolmen. Dating from the Stone Age, the dolmen is now located in the middle of a modern housing estate, aptly called Cromlech Fields. The entrance to the Dolmen faces east..

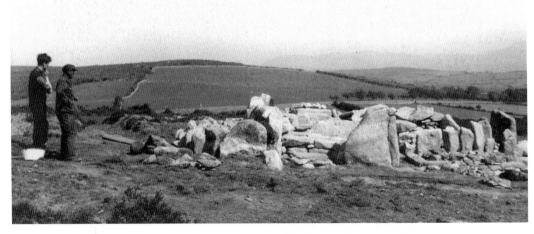

Ballyedmonduff wedge tomb. Dating from the early Bronze Age, this megalithic wedge tomb has an entrance facing west, perhaps towards the setting sun. Ballyedmonduff, near Glencullen was excavated in 1945; some pottery, a stone mace head and some cremated human remains were discovered on the site.

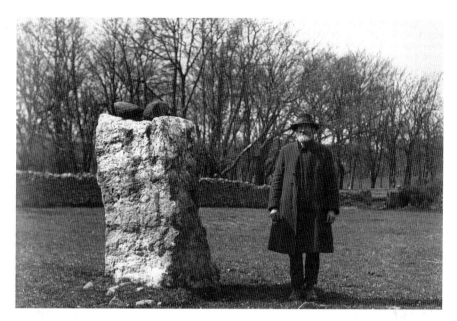

Standing Stone, Glencullen. This stone, known locally as 'Queen Mab' stands 1.83m high. It may date from the Iron Age or earlier. Local folklore has it that it was used with another stone by the Danes to play a game known as *Rings*. It is rumoured to penetrate the earth by more than twenty feet underground and it is also said to have magical powers. The man standing beside it is Peter O'Neill, a local farmer.

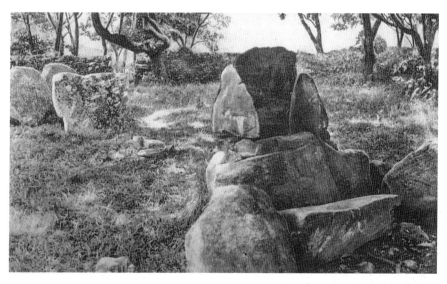

Druids Chair, Killiney. The current monument dates to the Victorian period when the site was disturbed and the Druid's Chair, also known as the Druid's Judgement Seat, was built from the excavated stones. In the eighteenth century the site was described as - "three small cromlechs surrounded by a circle of upright stones, about 135ft in circumference … it was assumed to be a pagan temple". The area around Killiney has long been reputed to have mystical associations. A well-known pub on Killiney Hill Road is called the Druid's Chair.

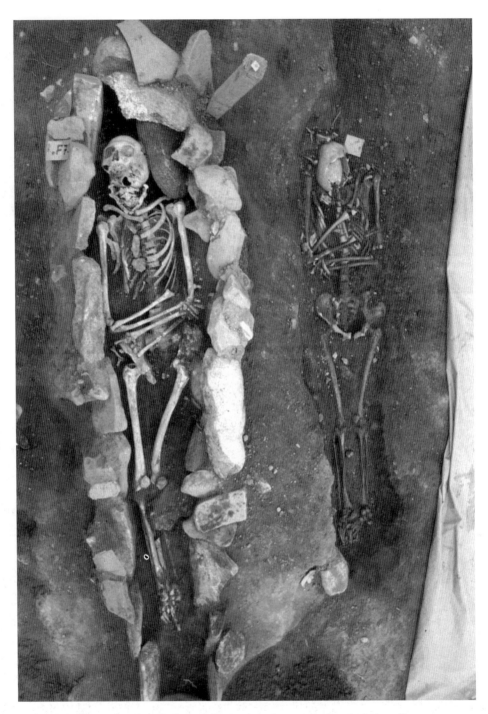

Human remains. Over 1500 cabinteely skeletons and numerous archaeological artefacts were uncovered from part of an ancient cemetery at the site of the Esso service station in Cabinteely. The burial site seems to have dated from the late fifth or early sixth century up to the late twelfth century. This skeleton in its stone lined grave appears to have been buried to its side. The skull has been turned around which may mean that it is the remains of someone who was decapitated.

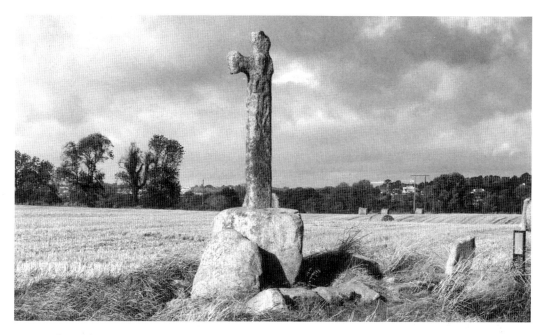

Tully High Cross. Located near the Church at Tully, this High Cross dates from the twelfth century. Made out of granite it bears the figure of a bearded bishop wielding a crosier. It may represent St Laurence O'Toole who was Archbishop of Dublin from 1162 to 1180.

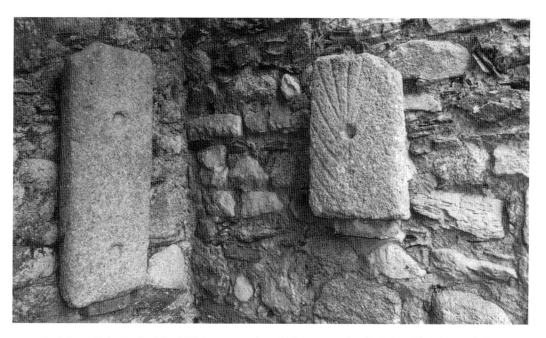

Rathdown Slabs, Rathmichael. Unique examples of Viking art styles depicting Christian symbols not found elsewhere in Ireland. Located at Church sites at Ballyman, Dalkey, Kilgobbin, Killegar, Kiltiernan, Rathmichael and Tully, they highlight the strong associations the area had with the Viking settlements and its influence on early Christian art.

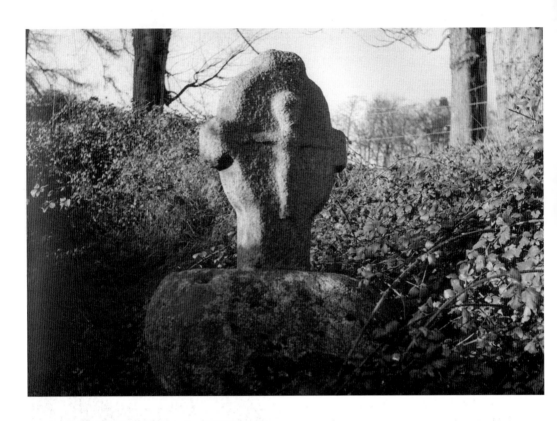

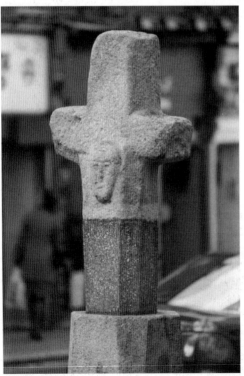

Above: Rathmichael Cross. A granite cross with crucifixion scenes on both sides, it is one of a number in the area that are very similar in style.

Left: Blackrock, Market Cross. The Market Cross in Blackrock is also very similar to the Rathmichael and Kiltuck Crosses. They are known as Fassaroe crosses and may all be the work of the same stonemason. It is now located in the middle of Main Street, Blackrock.

Right: Kilgobbin Cross, located near Kilgobbin Church, Stepaside, the south arm of the cross is missing. On the east face is a robe-clad figure of Christ. At the foot of the cross is a bullaun stone. A 'bullaun' is a hollowed out basin in the stone. It can be seen just to the right of the cross.

Below: St Begnet's. Generally known as St Begnet rather then St Benedict, St Begnet's is associated with the Dalkey area. St Begnet is one of those elusive saints whose identity and indeed gender is in some doubt though it is generally believed that she was an Irish princess who lived in the seventh century. There are varying accounts of her life and her connection with Dalkey is unclear. The church on Dalkey Island dates from the eleventh century, though there may have been a timber structure there before that. A Martello Tower was built on the island at the beginning of the nineteenth century. Over the years Vikings, pirates and plague victims have been linked with the island.

St. Benedicts Chapel, Dalkey Island

1690 Battle of the Boyne

DR PADRAIG LENIHAN

This book depicts the Battle of the Boyne: a battle that is commemorated every year and the largest battle in Irish history, it concluded the English war of succession, securing a Protestantmonarchy in England.

0-7524-3304-0

A History of the Black Death in Ireland

MARIA KELLY

Maria Kelly goes in search of the 'Great Pestilence' whose consequences are often obscured by the intricate and tumultuous history of the time and traces how the Irish reacted to this seemingly invisible killer.

0-7524-3185-4

A History of Bray

ARTHUR FLYNN

This comprehensive volume recalls shops, businesses, churches, schools and some of the events that have occurred in the town. It also describes the lives of people who lived in the area over the centuries.

0-7524-3269-9

Lismore

EUGENE F. DENNIS

Founded in the seventh century by St Carthage, Lismore takes pride in its traditions. This collection of over 200 photographs recalls aspects of everyday life in Lismore, including work, education, arts and sports. These old Photographs capture the town and its locals at their charming best.

1-84588-501-5

If you are interested in purchasing other books published by Nonsuch, or in case you have difficulty finding any Nonsuch or Tempus books in your local bookshop, you can also place orders directly through our website
www.tempus-publishing.com